£4-50
1/18

THE TROSSACHS

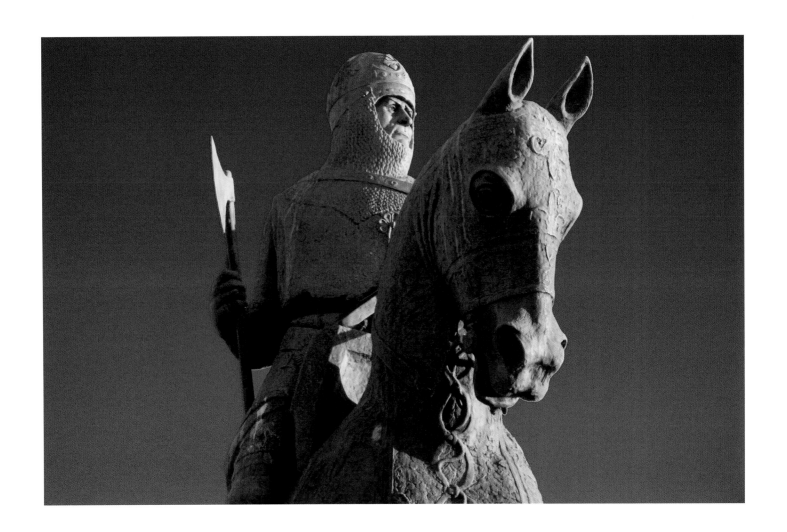

The Robert the Bruce Monument at Bannockburn

THE TROSSACHS

PHOTOGRAPHS BY
ALLAN WRIGHT

WITH AN INTRODUCTION BY
RENNIE McOWAN

First published in Great Britain in 2005 by

Birlinn Ltd
West Newington House
10 Newington Road
Edinburgh

www.birlinn.co.uk

ISBN10: 1 84158 354 5
ISBN13: 978 1 84158 354 9

British Library Cataloguing-in-Publication Data
A catalogue record for this book is available on request from the British Library

Design by Andrew Sutterby

Printed and bound by L.E.G.O, Italy

PREFACE

IT WAS AN IMPORTANT moment for me when, in the spring of 2004, Birlinn asked me to produce images for a photo essay on the Trossachs; I saw the offer as an honour and a privilege. Over the years I had almost imperceptibly evolved my hobby/passion into a profession but I had done this for the most part by self publishing. I did not hesitate to say yes to the offer as there was something clear and refreshing about taking on a well defined job for someone else.

In looking for boundaries to define this task I quickly concluded that the Trossachs is more a perceived area in the hills and Lochs north of Glasgow and West of Stirling rather than a geographic absolute, an area highlighted by names such as Katrine, Menteith, Ledi, Venacher and Venue. As you will see the remit has in fact been extended to encompass both Stirling in the east and Loch Lomond in the west. There is I sense a natural connection among these lands.

So I jumped straight into the heart of this beautiful landscape in the spring of that year and started looking. I looked behind the usual landmarks, I looked closer for new energy occurring in seasonal colour, I looked at the sky almost constantly, and I walked, cycled, hacked through the copse, over the Knoll, behind the shed and round the back of the farmyard. I also spent countless hours driving, driving hundreds and hundreds of miles. If there was a track I drove or cycled along it, if there was shore I walked round it, at all times watching, listening, wait-ing, sometimes returning to the same spot perhaps 4-5 times.

My companion throughout this project was Tara my little black lab. She knows the game well, we hunt together, she knows the rules and she shares her passion for landscape with me. Together we set out in search of the heart of the Trossachs. For me this heart is an essence distilled from lochs, hills and woods but it has a special flavour, a feeling you get when the word is said, the images flow and any journey into the Trossachs any time will reinforce it. I set out like any other tourist to find it – I was lucky perhaps I was getting paid and I had a year to do it but did we succeed? You can be the judge of that. I'd do it again any time.

Allan Wright

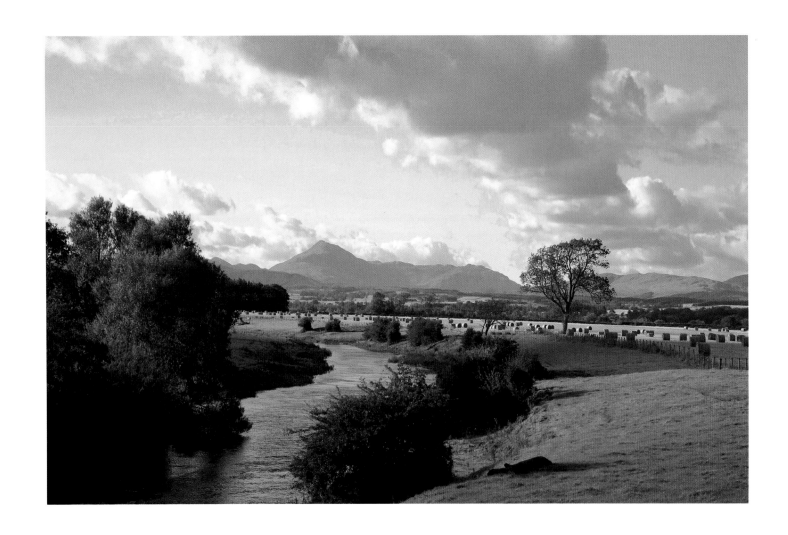

The River Forth at Gargunnoch looking to the Trossachs hills

INTRODUCTION

A LOT OF BENEVOLENT ghosts hang around the Trossachs, that beautiful frontier area on the fringe of the Southern Highlands. They include clans people and engineers, monarchs and cattle drovers, writers and shepherds, poets and mountaineers, foresters and geologists, and, yes, faeries and goblins, and some of the categories are still around today.

This is one of the busiest tourism centres in Scotland and yet there are many delectable corners where solitude can be found – if desired – as Allan Wright's superb photographs show. There is a wonderful mix of loch and hill scenery, of woodland and moor, where the light can alter within minutes, presenting an ever changing scene. The Trossachs landscape is never dull. Allan captures this with great skill.

The character of the Trossachs has changed over the years as a result of the growth of modern forestry, the creation of a roads system and lochs being turned into reservoirs to provide water for the great city of Glasgow and nearby towns, and yet the area can be accurately said to be 'wild'.

There are still red deer on the hills and golden eagles in the sky. The persecuted fish hawk, the osprey, is back and the rich mixture of high mountains, 'managed' forests, silver and blue lochs, wild woodland and heather moors provide a haven for many birds and animals. Go quietly and look well. Allan Wright has what the Gaelic people of old called 'the seeing eye' as his exquisite pictures show.

Yet there is room for holiday exuberance as well, and one of the most cheerful sights in the Trossachs is to see whole families hiring bicycles at the east end of Loch Katrine, a spot known as the Trossachs pier, and then boarding a small steamship to sail up the loch, embarking at its head, and then pedalling back on the water authority's private road upon which cars (except local farmers and water board staff) are banned. In the evening, there are ceilidh dances in many hotels and if you don't know the dances, some amiable neighbour will guide/push you through them,

The steamer is appropriately named *The Sir Walter Scott* after that great writer who set much of his epic poem of war and romance, 'The Lady of the Lake', around Loch Katrine and neighbouring Loch Achray. Its publication in 1810 sent hundreds of new visitors to the Trossachs and he can rightly be called one of the fathers of Scottish tourism.

I can't hear on TV the stirring march played for the 'entry' of American presidents, 'Hail to the Chief', but I think of Sir Walter because it is taken from 'The Lady of the Lake', and the poem also inspired Schubert to write 'Ave Maria' because it includes a prayer which caught the composer's attention. He was a great admirer of Scott and it is intriguing to think that two of the world's best-known pieces of music have their roots in the Trossachs.

There is some argument nowadays as to what constitutes the boundaries of the Trossachs, originally regarded as the area around Loch Katrine and Loch Achray, and the meaning of the name is generally taken to be 'the bristly ground'. Nowadays, tourism writers include the town of Callander which is remembered by many people as the site of the much followed BBC-TV serial, 'Dr Finlay's Casebook', which featured the grumpy, but lovable Dr Cameron, handsome Dr Finlay and their pawky housekeeper Janet, and which was loosely based on the writings of A.J. Cronin. Callander also has a visitor centre which features the life of the Highland Cattle drover, warrior and folk hero, Rob Roy MacGregor, who was born on the shores of Loch Katrine and was married at a farm close to neighbouring Loch Arklet.

People scoff nowadays at faery folklore and that's a pity because the Trossachs area is full of such sites, including the stony hillsides of the Goblins Corrie, on Ben Venue, where these strange beings were reputed to hold an annual convention.

Also within the modern Trossachs is the forestry village of Aberfoyle where there is a Scottish Woollen centre and a nearby knoll called Doon Hill with a tall pine tree sticking out on top. The tree is known as the Minister's Pine because in the 17th Century the local clergyman and Gaelic scholar, the Rev Robert Kirk, is reputed to have been transported there by faeries, even though his grave can be seen in Aberfoyle. He wrote a book called *The Secret Commonwealth* which described their way of life, placing them between the human race and angels and they were seriously angered by their secrets being revealed. His book has an international reputation in folklore circles.

My wife and I went a short walk there one afternoon and noticed that visitors had tied small pieces of cloth to the pine tree and its neighbours, some accompanied by written messages, a growing modern version of prayer flags.

When we examined these, we suddenly heard ethereal voices in the sky and on scanning the heavens we eventually found there was a grinning youth three quarters of the way up the tree.

Some visitors and writers feel the Trossachs area should also now include the forestry village of Strathyre, reaching almost to the Braes of Balquhidder, and also to Lochearnhead to the north and the Lake of Menteith to the south and even to the fringes of Loch Lomond. It's all good for an argument and my own, personal view is that the 'real' Trossachs is the area around Loch Katrine and Loch Achray and the other areas are modern 'associates' of real relevance.

My own acquaintance with the Trossachs dates from childhood, attending a residential school camp at Dounans, near Aberfoyle, and in an early geography lesson abandoning copying a map of part of the Sussex coastline and turning (without permission) to a map of the Trossachs and copying that instead, colouring blue the evocatively named Lochs, Katrine, Achray, Venachar, Ard, Chon, Lomond, Arklet, Lubnaig, The Lake of Menteith and little lochans in lonely corners and drawing a green triangle on the hills, Venue, Ledi, Ben A'n, the Menteith Hills and sundry others.

It all evolved into years of pleasurable walking and climbing, joyfully standing on summits, exploring passes and the woods, experiencing loch-

side picnics and sitting out all night on hill tops to experience the dawn and the sun coming up.

The Trossachs cannot be exhausted in any person's lifetime. Author Alan Paton wrote in one of his novels about apartheid in South Africa that the people regarded a range of hills as being beautiful 'beyond any singing of it'. That can also be said of the Trossachs hills in certain lights and selected seasons, and a galaxy of people have been ready to set down in print their praise of the area.

They've either written travelogues, poems, diaries, letters or used this corner as a background for plots and stories, but one way or another the area left its mark on them. Some have had a moan about the weather. As well as Scott, they include Jules Verne, DK Broster, Charles Dickens, William and Dorothy Wordsworth, James Hogg (the Ettrick Shepherd), Robert Louis Stevenson, RB Cunninghame Graham, Samuel Taylor Coleridge, and Gaelic poets like the 18th century evangelist Dugald Buchanan who is buried on the fringe of Callander and who is commemorated in a monument in Strathyre village.

The artist John Everett Millais came here on holiday in 1853 with his friends John Ruskin and Ruskin's wife Effie, staying at Brig o' Turk village at the foot of Glen Finlas. A torrid and smouldering love affair developed between Millais and Effie, the biggest scandal of its kind since Byron's time. It's a heady place, the Trossachs.

Modern visitors bothered by that scourge of the Highlands, the midge, might be amused by the thought of Ruskin, Millais and Effie walking up Glen Finlas with gauze nets over their faces and looking like the Invisible Man of the old TV series of that name.

This much loved and much praised area now has new administrative structures for special planning and land management protection; the Queen Elizabeth Forest Park, sited close to Aberfoyle, and the recently set up Loch Lomond and Trossachs National Park, the first such park in Scotland.

Trossachs-lovers all have their favourite corners, some big, some small, and Allan Wright's discerning eye has picked out a series of jewels, of cameos, from a vast treasure chest.

To look and look again is to re-kindle old memories and to savour them and also to plan afresh to find new delectable corners in this unforgettable landscape.

Rennie McOwan

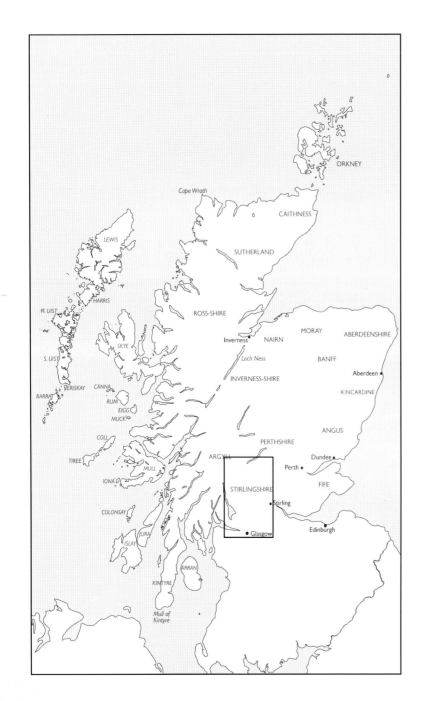

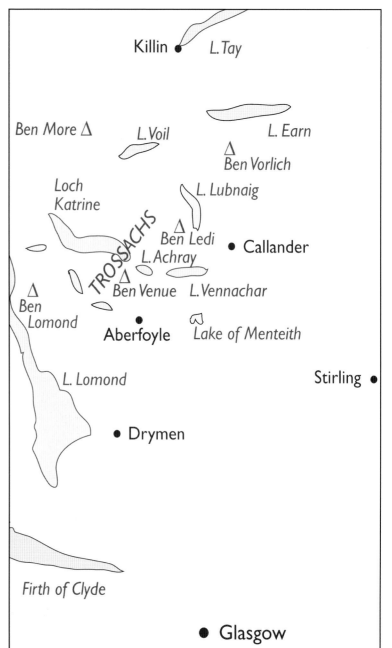

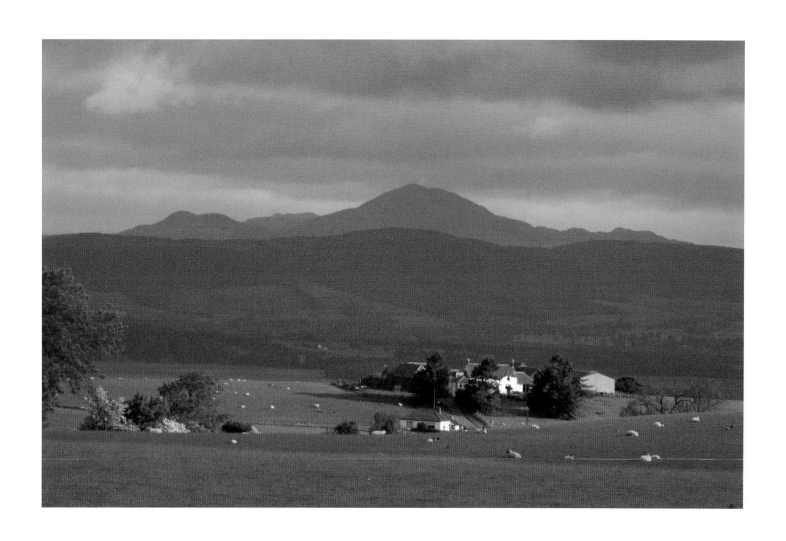

Approaching the Trossachs from the south here at Buchlyvie, Ben Venue beckons in the distance

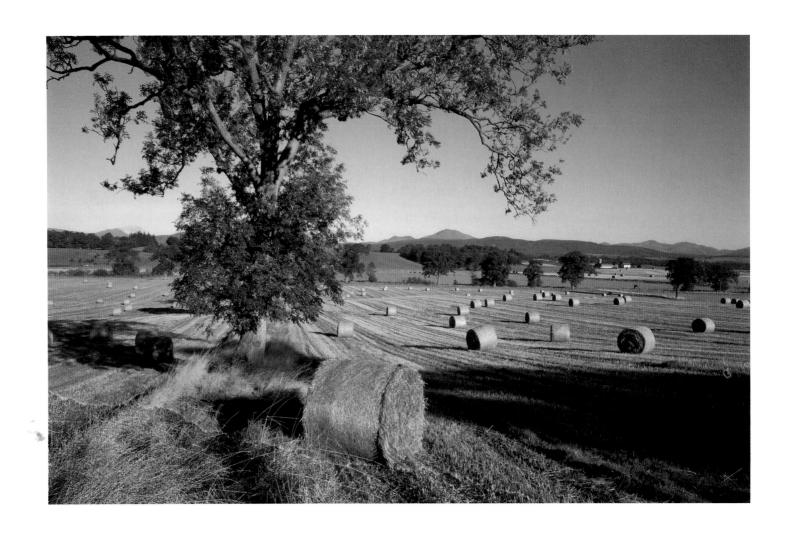

Arnprior in late August and barley straw bales blend with rolling and fertile lands below the Fintry Hills

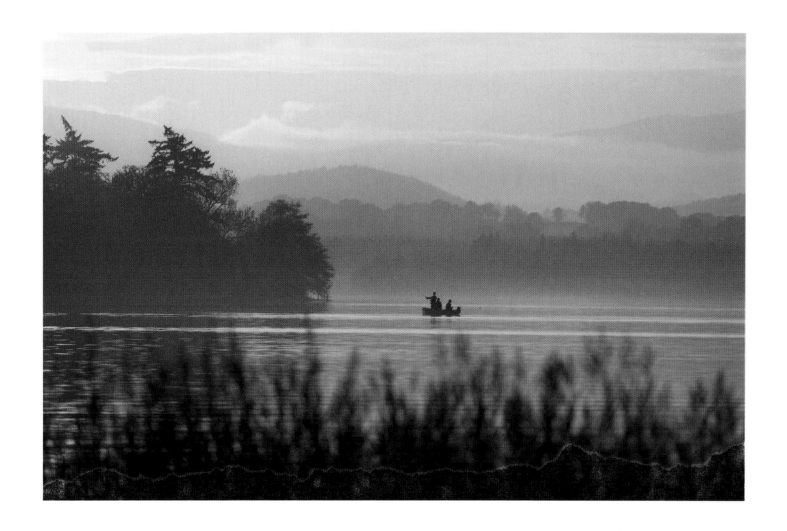

Late casting on the Lake of Menteith, Scotland's only lake

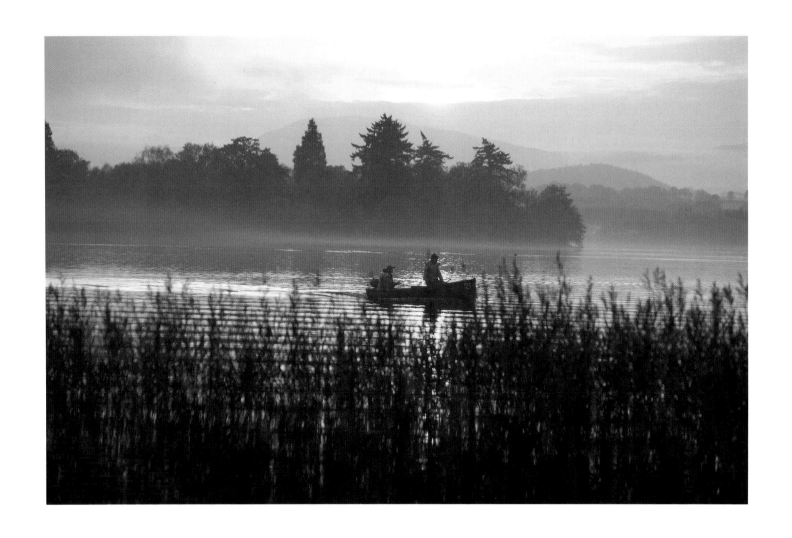

Sundowners are taken whilst heading back to the Port of Menteith

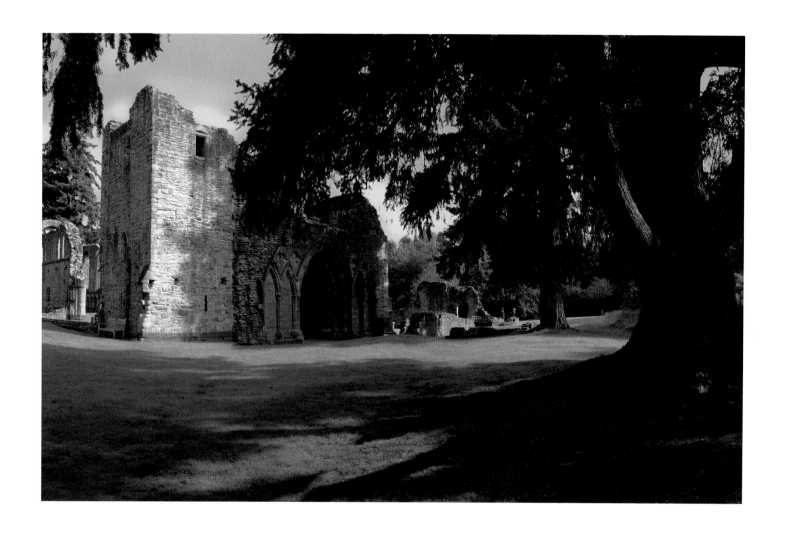

The graceful ruins of Inchmahome Priory situated on its own island on the Lake of Menteith

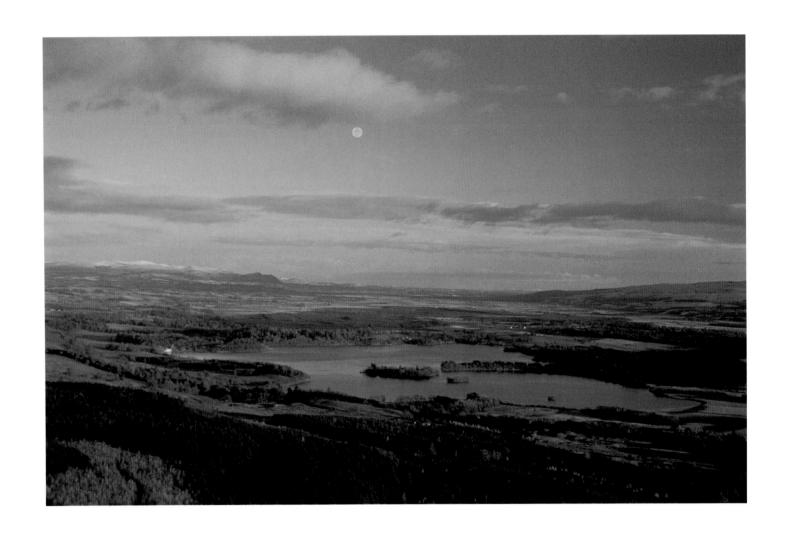

Moonrise over the Flanders Moss and The Lake of Menteith looking east

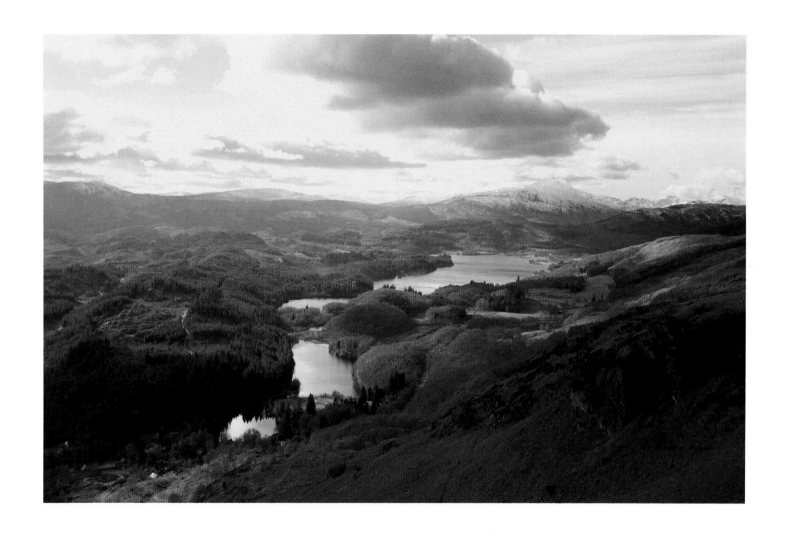

From Craigmore above Aberfoyle there lies a classic view to Ben Lomond across Loch Ard

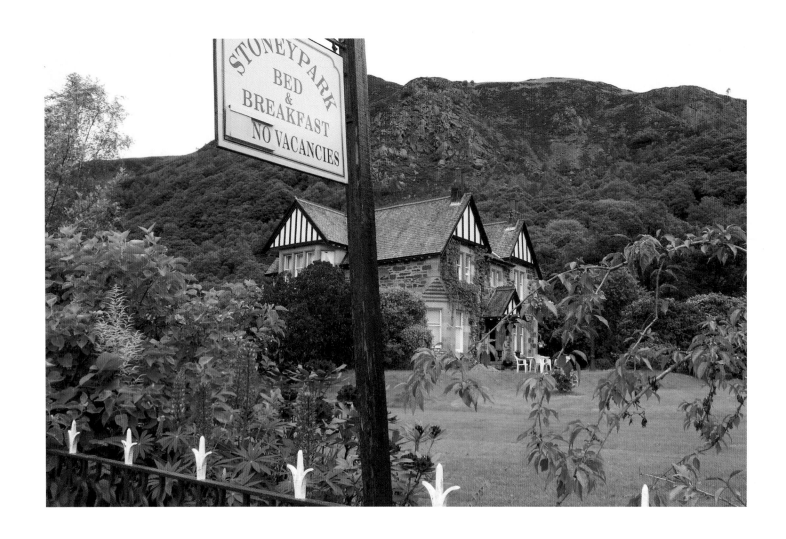

The Trossachs supports an abundance of fine B&B establishments like this handsome villa near Aberfoyle

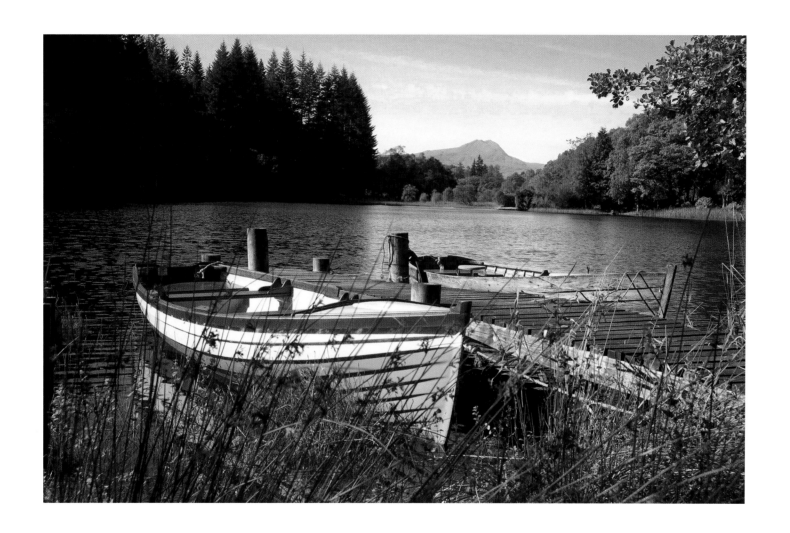

A manicured loch side and a comfortable little jetty combined with the Ben Lomond's presiding backdrop offers a quintessential Trossachs image at Milton on Loch Ard

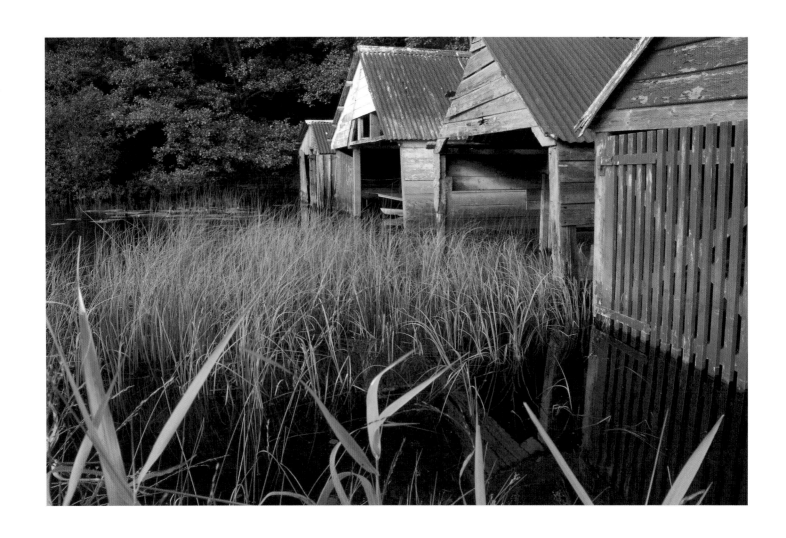

Boat houses with a dignity redolent of a more genteel era nestle amongst the reeds at Milton, Loch Ard

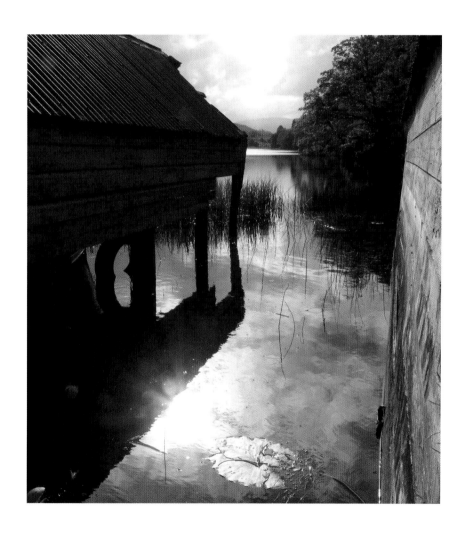

Between the boat houses, Loch Ard

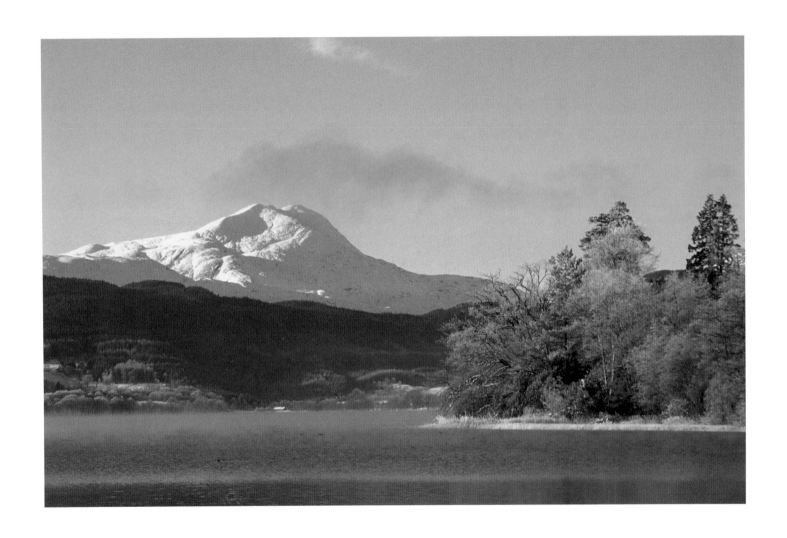

Ben Lomond presides over Loch Ard

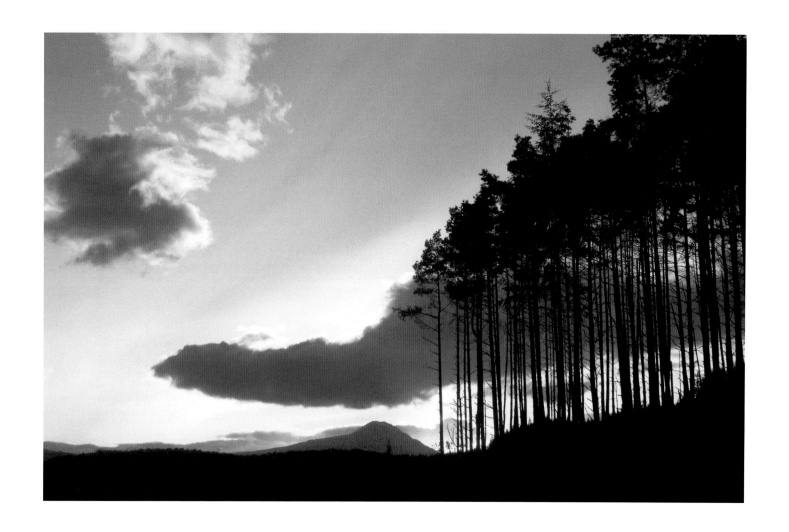

Like most other parts of Scotland the commercial forest at Loch Ard is getting a makeover in response to public demand for higher standards of aesthetics

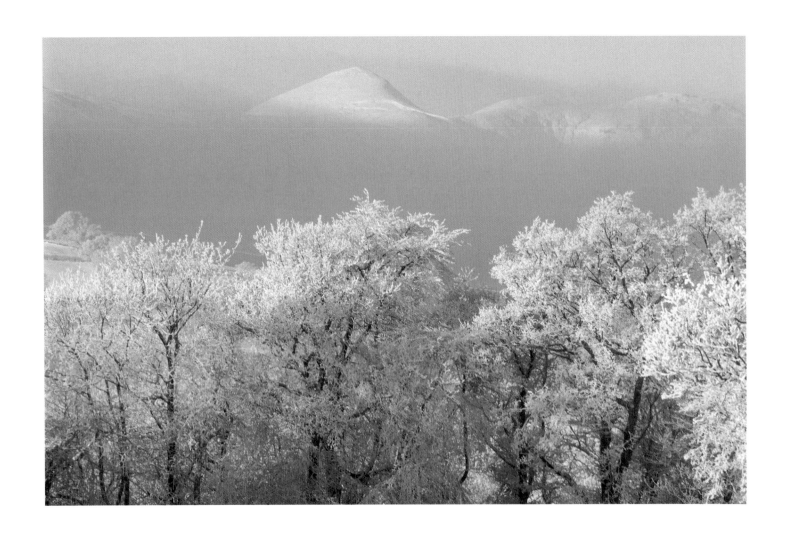

Ben Lomond evokes an almost Mount Fuji posture, midwinter, Loch Ard

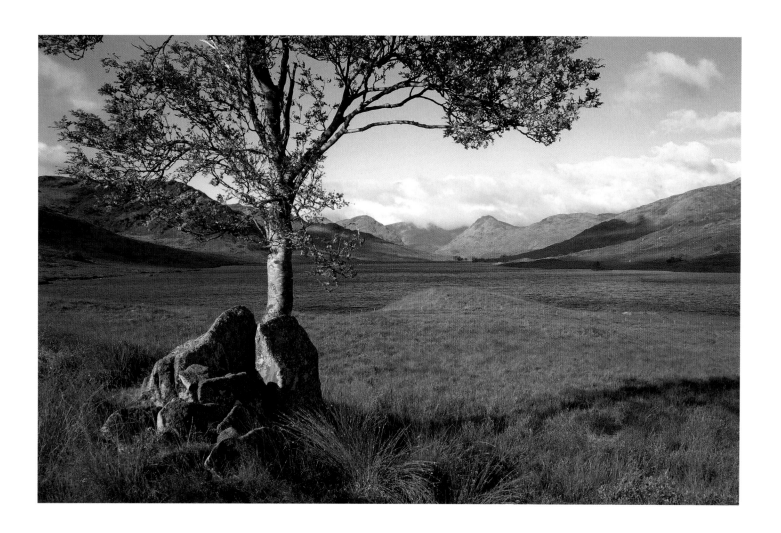

A berry-laden Rowan defines the classic vista across Loch Arklet to the Arrochar Alps on the far side of Loch Lomond

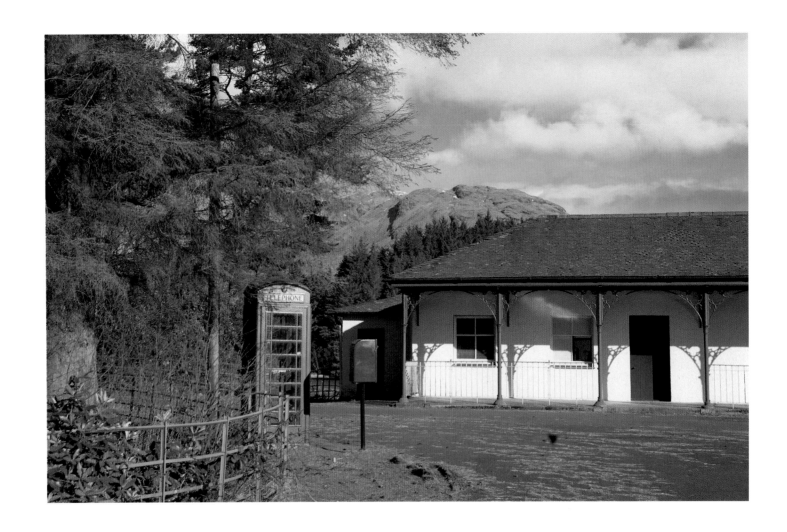

The waiting room at the port of Stronachlachar is purpose built with characteristically Victorian good sense

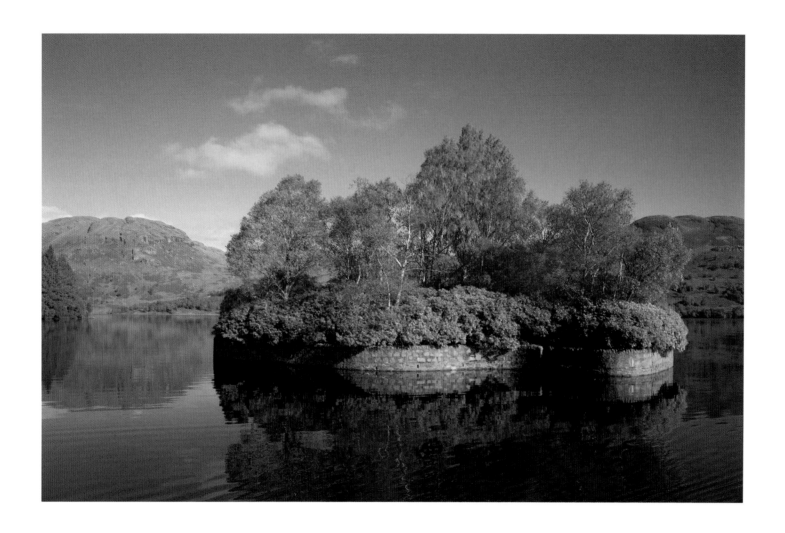

The Factor's Isle, Stronachlachar

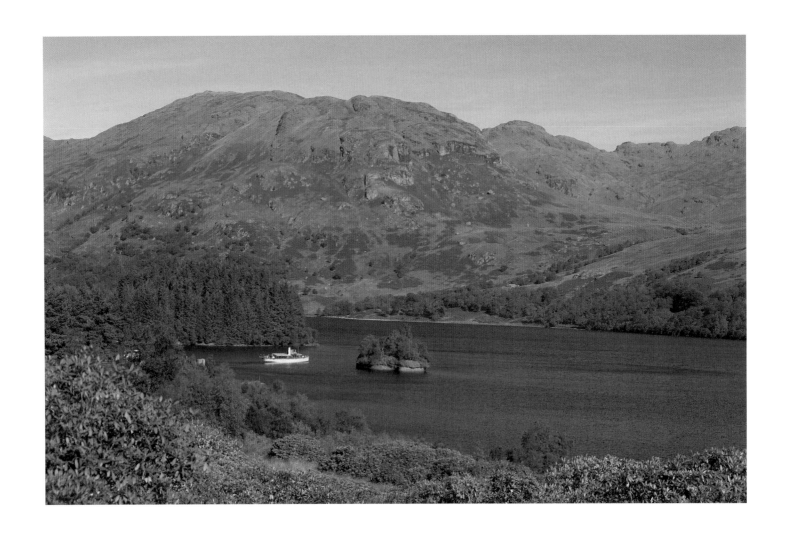

High summer and the SS *Sir Walter Scott* departs Stronachlachar for the return sailing to Trossachs Pier

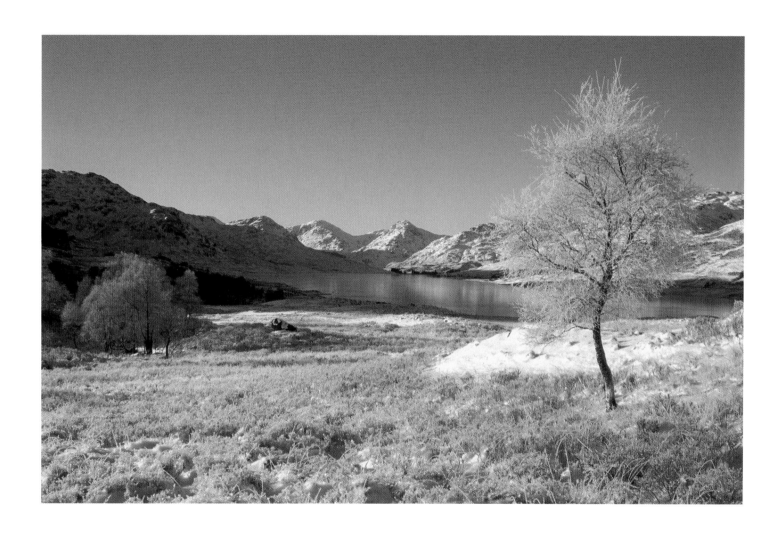

Any encounter with Loch Arklet is rarely less than breath-taking

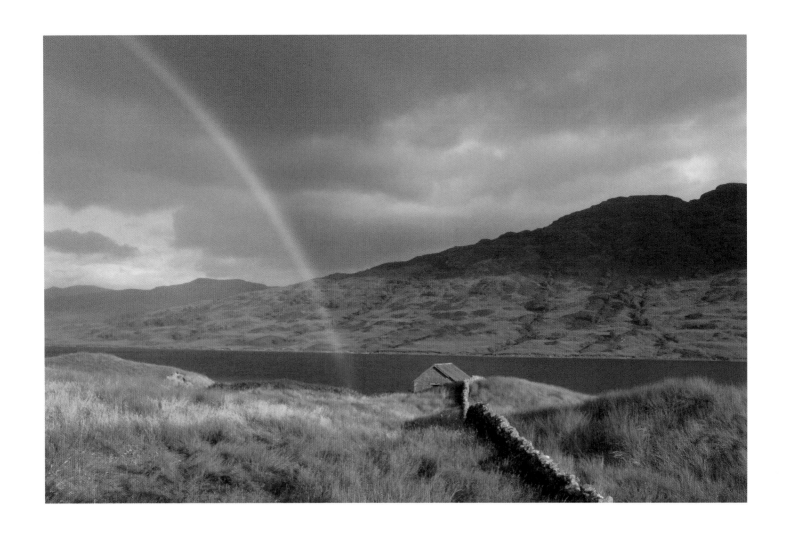

Fleeting light illuminates a graphic moment on the banks of Loch Arklet

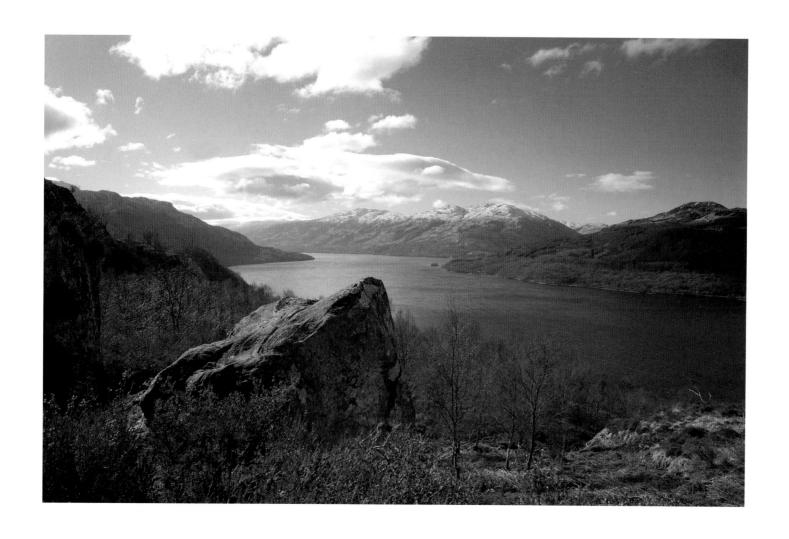

Looking south from Rob Roy's View above Inversnaid, Loch Lomond

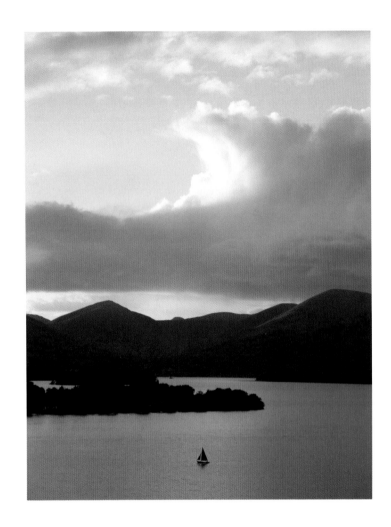

A lucky lone yachtsman is in the moment as a monumental evening sky evolves over the isles of Loch Lomond

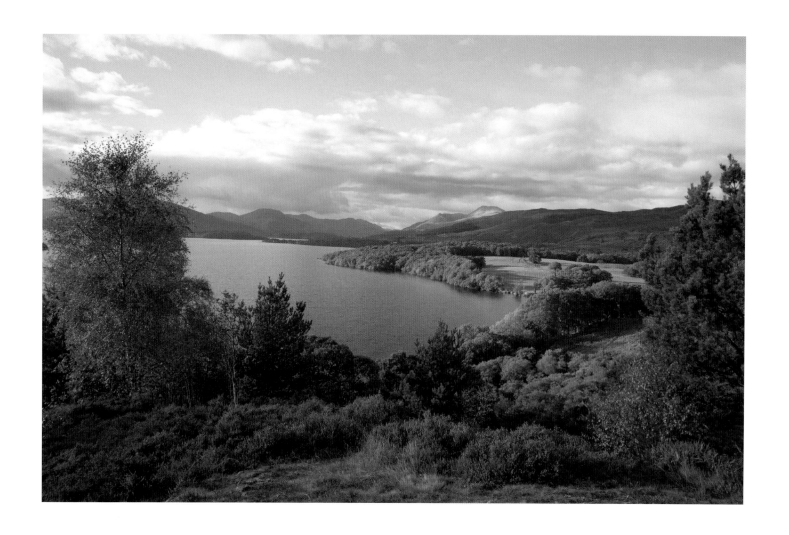

The gentle southern shores of Loch Lomond glow in the late afternoon light, Balmaha

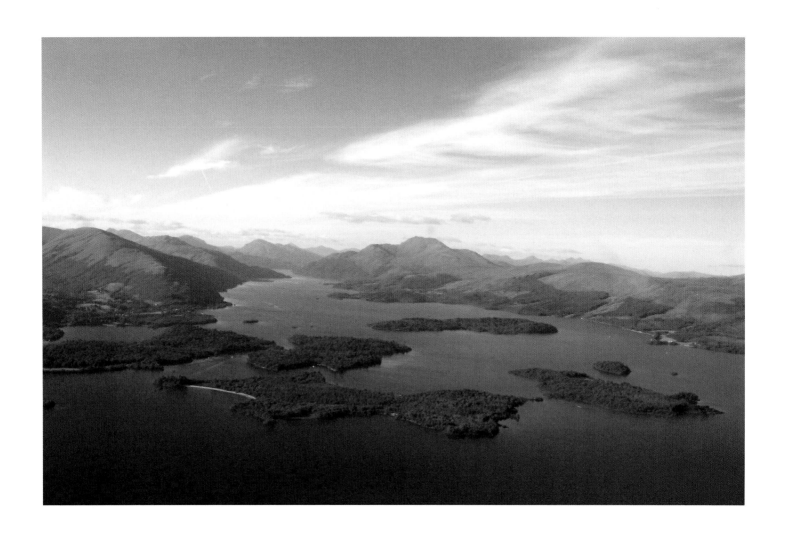

The islands of Loch Lomond are never more evocative than from the air

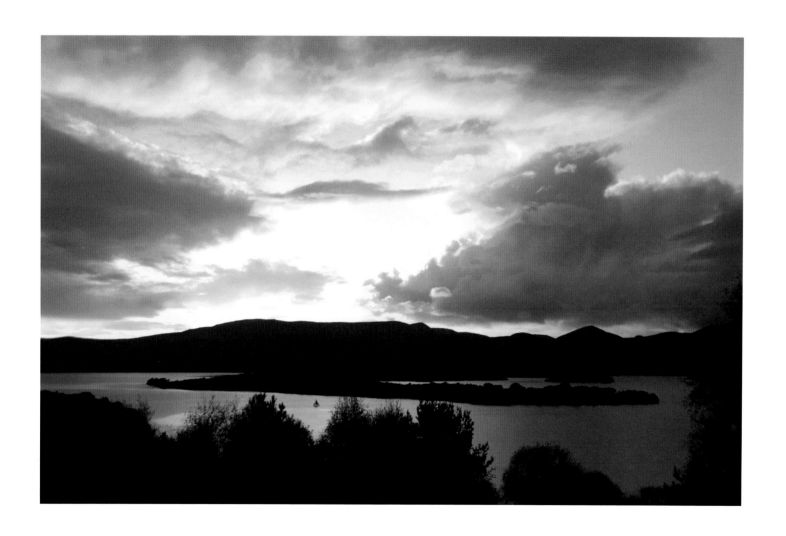

A fulsome sunset explodes over Inchfad

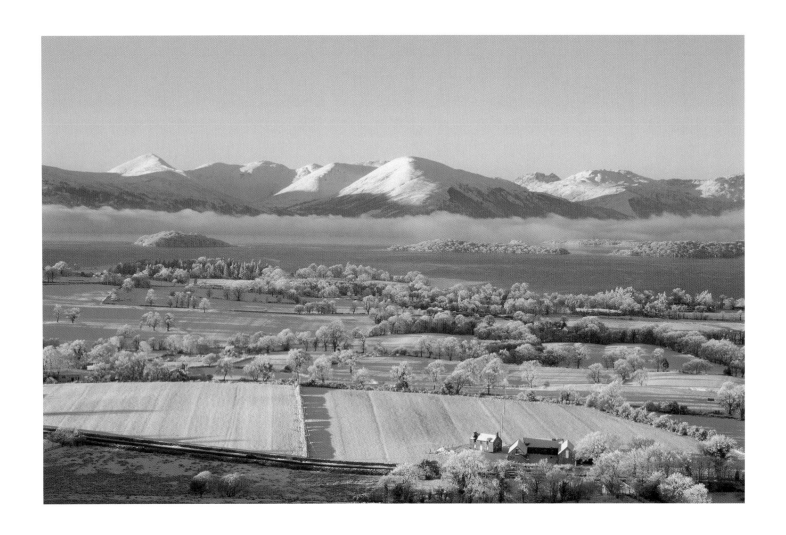

Midwinter from Duncryne Hill, Gartocharn

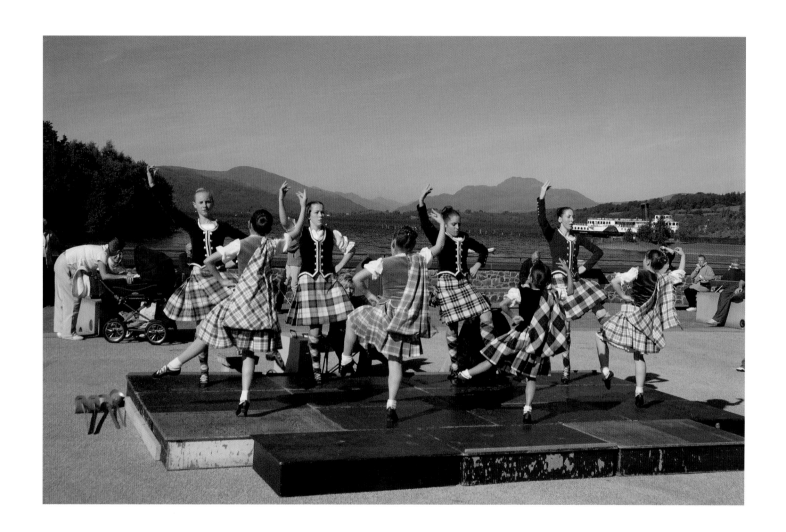

Bank Holiday at Loch Lomond, Balloch, and the tourists get just what they expected

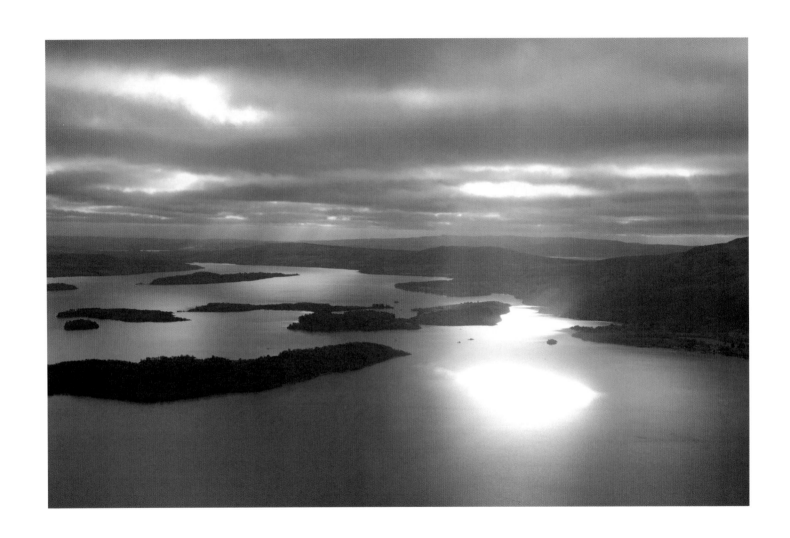

Dynamic light dances among the isles of Loch Lomond

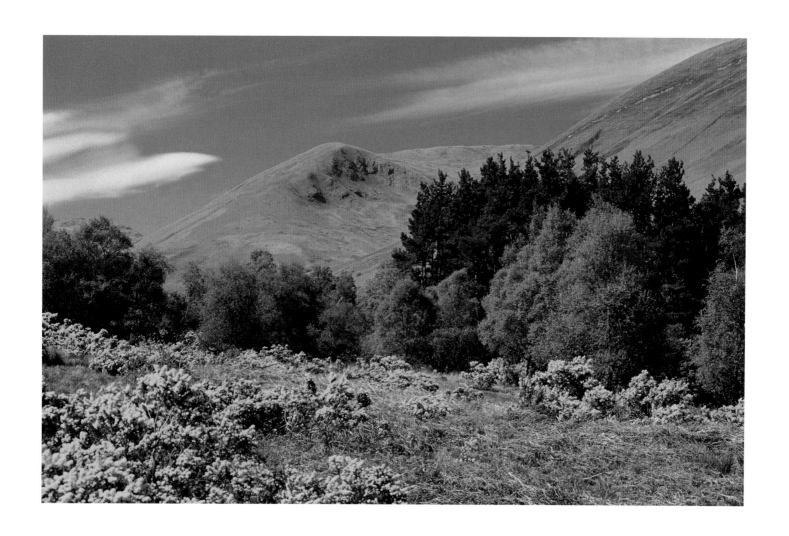

Mid May in Glen Luss and a full sun arouses the land. A coconut aroma wafts up from the whin and the call of the cuckoo emanates from deep in the wood.

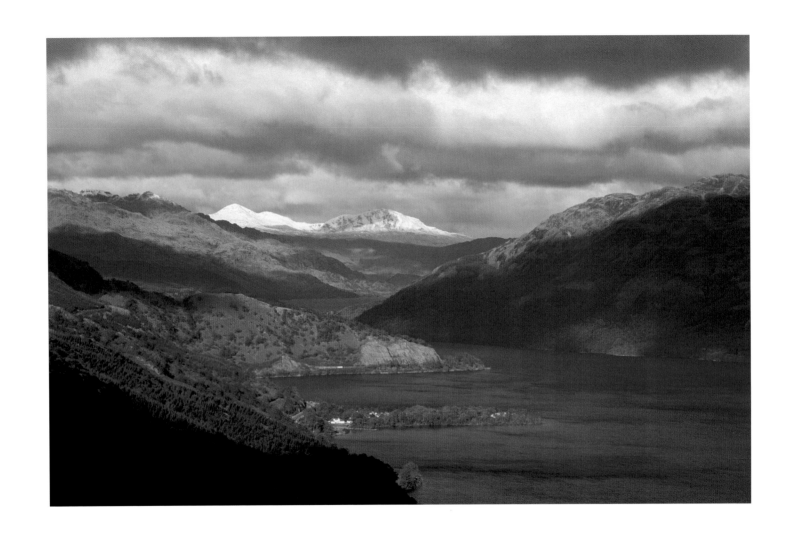

Beinn Dubh above Luss looking to the north, just at the interface of the seasons with greening trees around Inverbeg and the snow clad Arrochar Alps in the distance

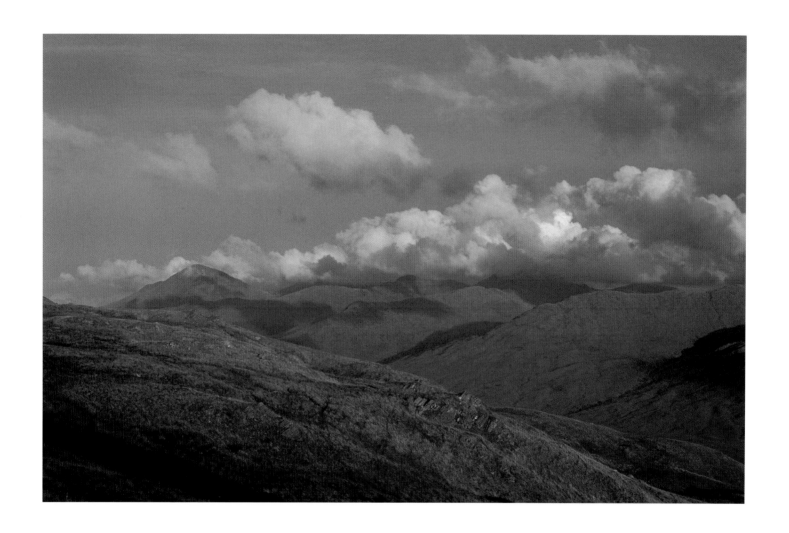

The high ground surrounding Loch Lomond is as rugged and barren as any Highland habitat. Rich late sunshine catches the topography around Ben Glas.

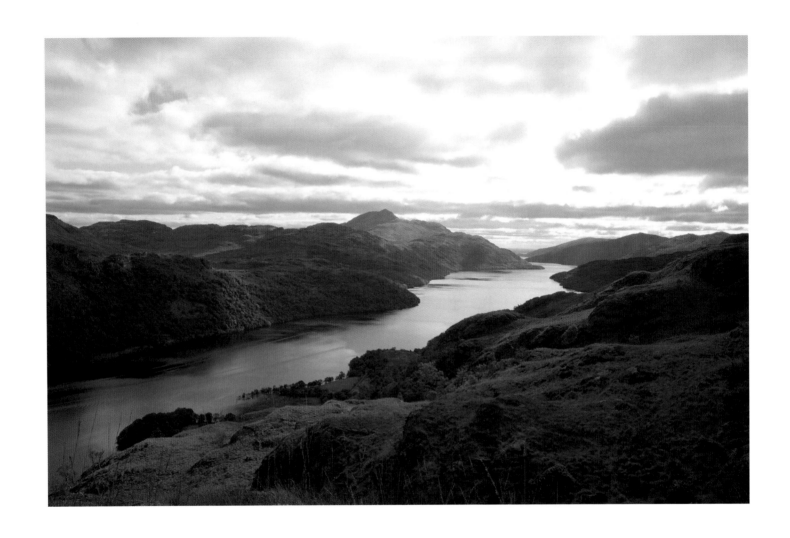

A stiff ascent past the power station above Inveruglas affords this fine vista centred on Ben Lomond

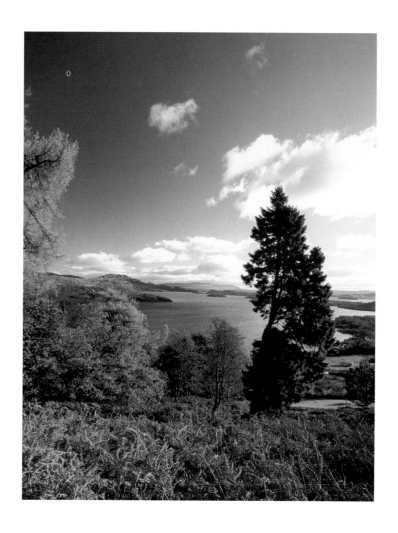

Brilliant autumn colour above Luss, looking south

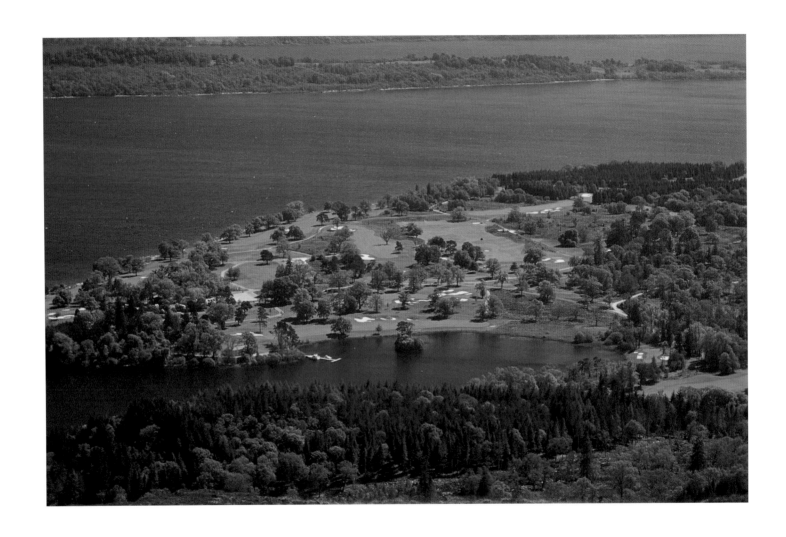

A superlative location for the great game, lush and tranquil is the setting for Loch Lomond Golf Course

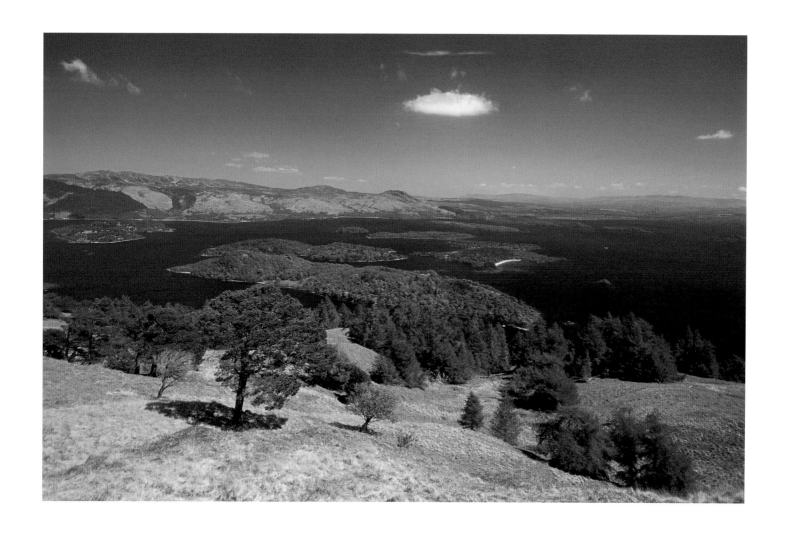

Looking across the complex of islands to Conic Hill from the west banks of Loch Lomond

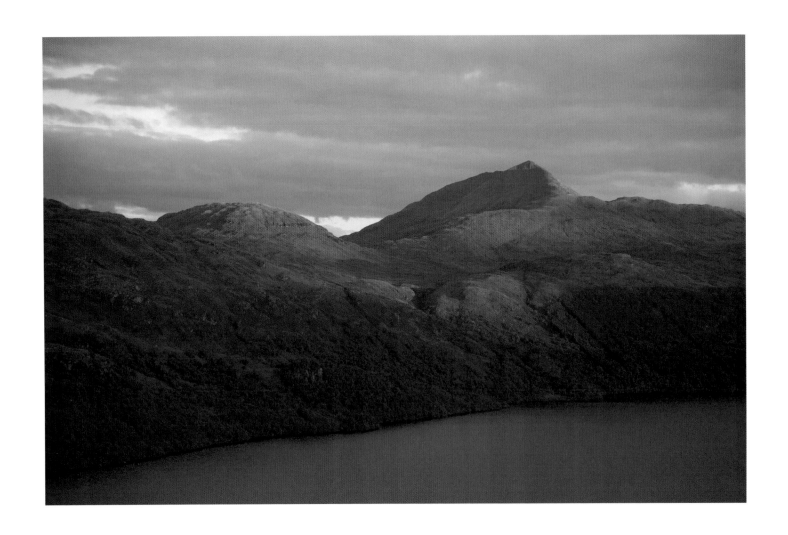

Warm dawn sunlight defines the muscled shoulders beneath Ben Lomond's familiar peak

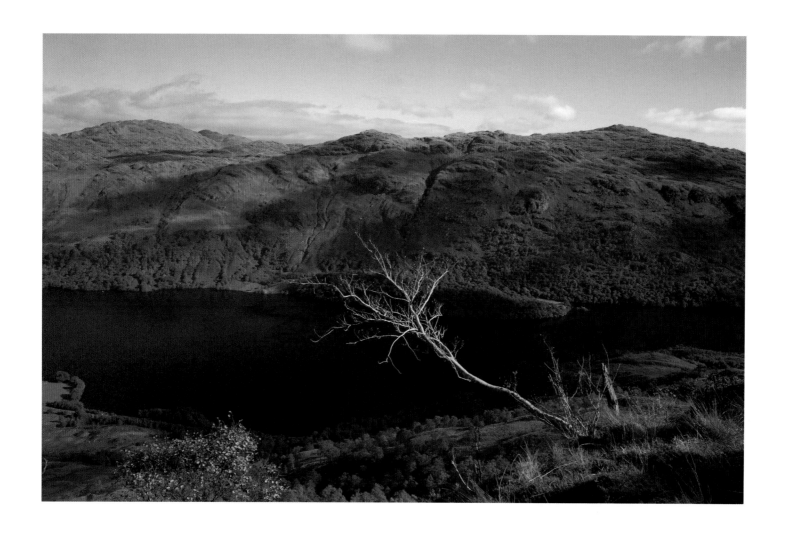

Crimson and spindly, a tenacious Rowan highlights the deep greens and blues of the northern slopes of the great loch, from the pulpit above Stuckendroin

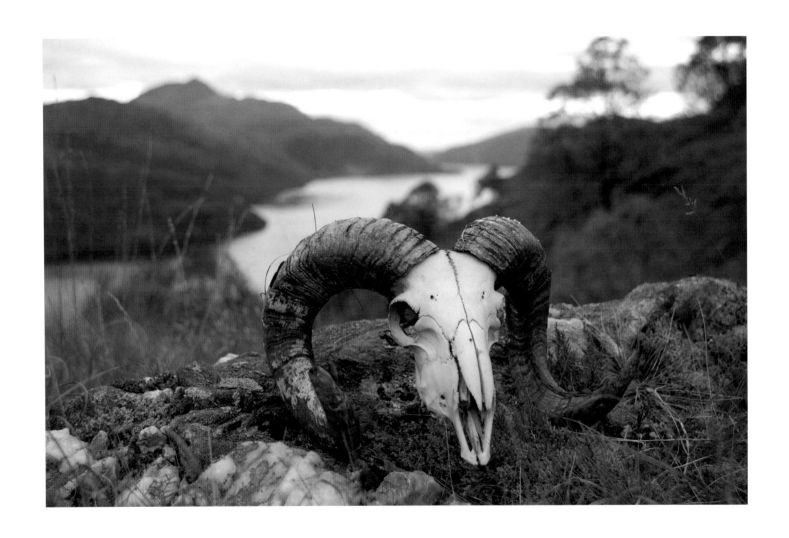

Across the hills of Scotland the ubiquitous Blackface sheep is rarely worth a second look, yet here with Ben Lomond as a backdrop, it has its moment, if only as a glaring but noble artefact

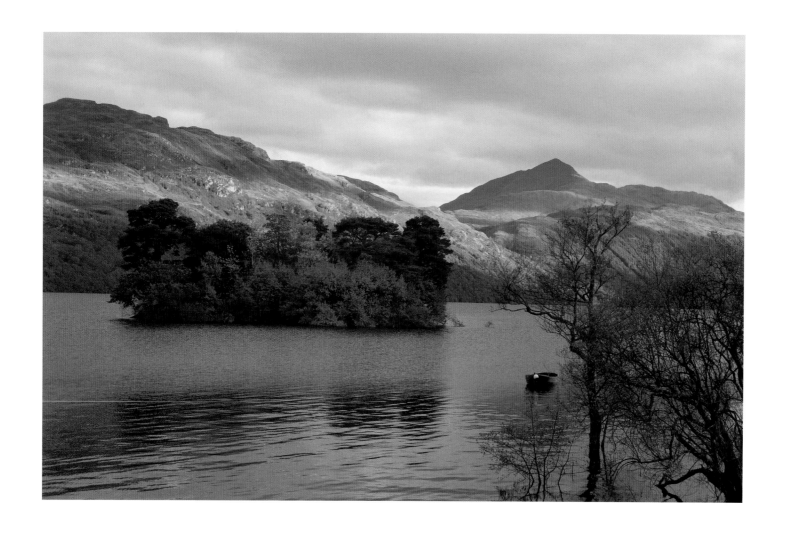

Inveruglas Isle

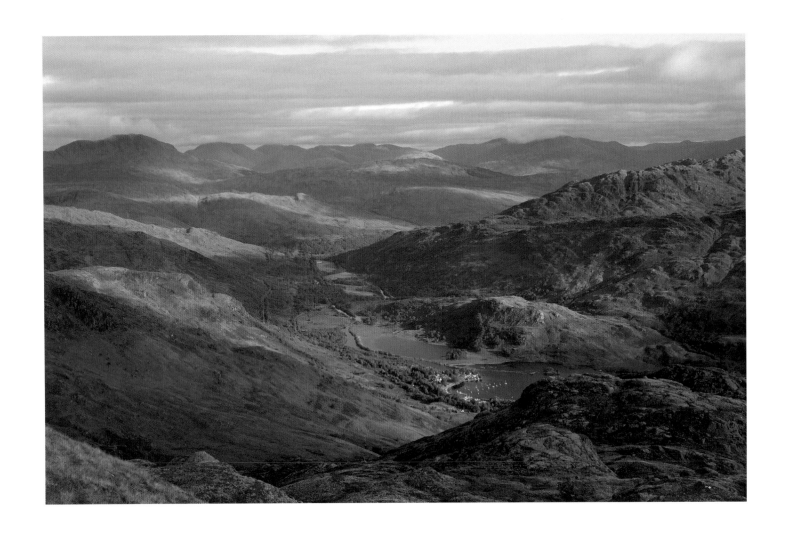

Ardlui marks the northern end of the loch, beyond there is the long ascent up Glen Falloch and the mountains of Crianlarich

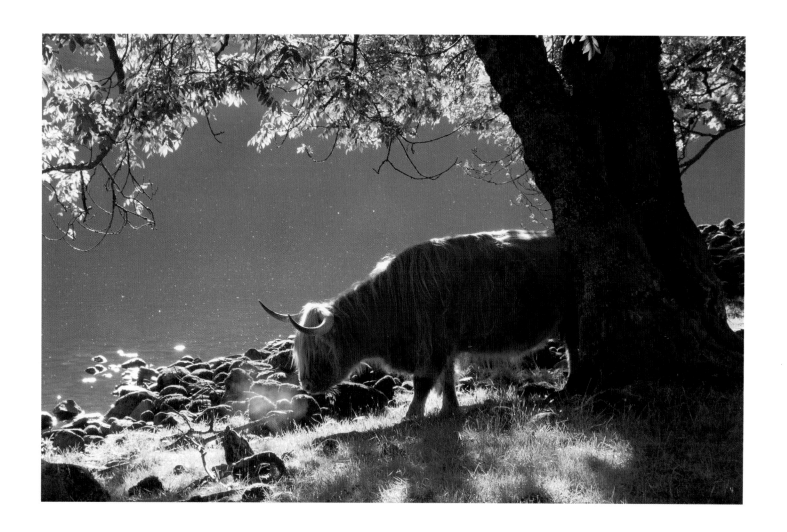

Stuckendroin by the bonnie bonnie banks and a gentle Highlander sniffs out fresh spring pasture

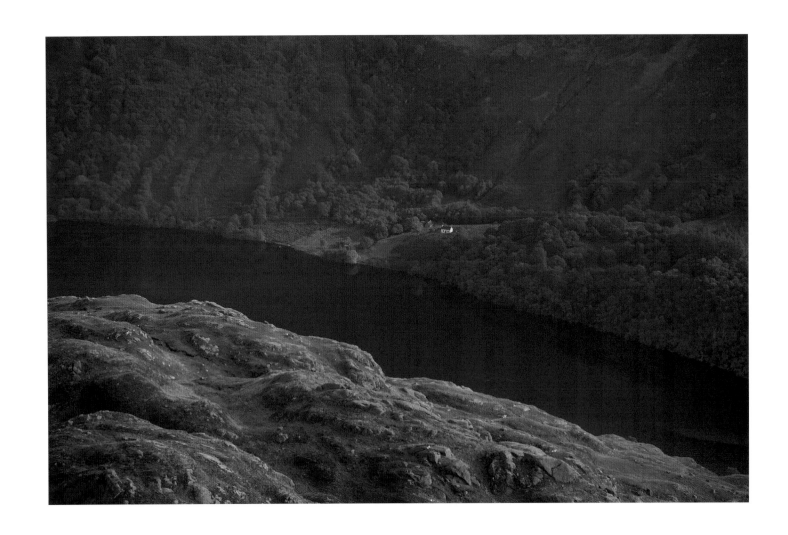

Splendid isolation at Doune Cottage on the West Highland Way

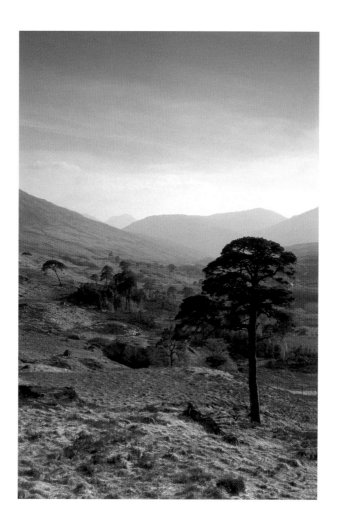

Glen Falloch has an eye-catching remnant of the great Caledonian Pine Forest.
Regeneration is underway and there are some elegant specimens to enjoy.

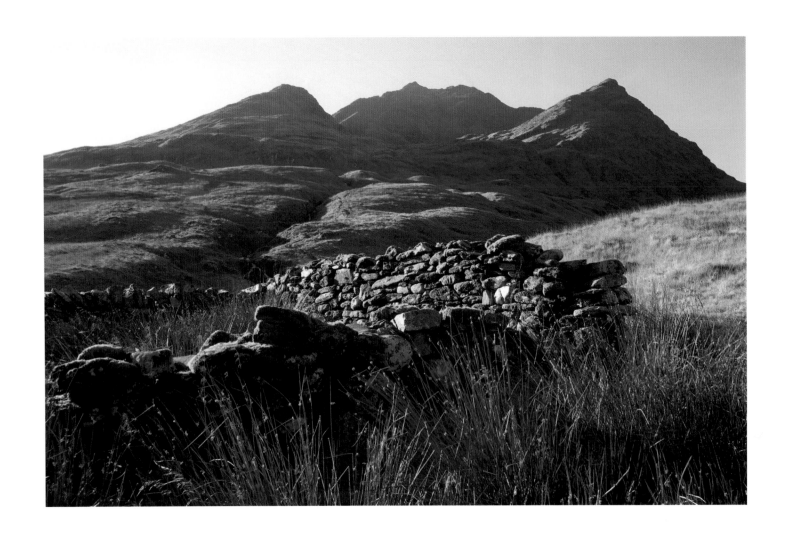

The 3 peaks of Ben Luis dwarf a pre-clearance ruin nestling at its foot

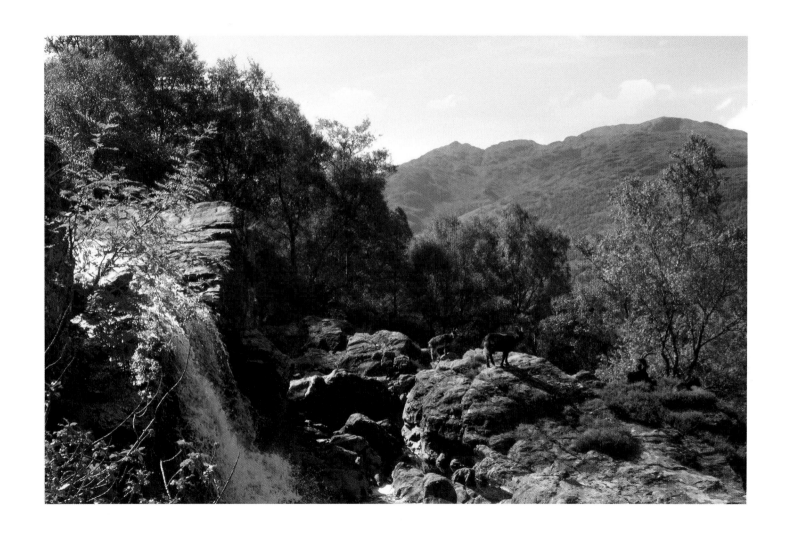

A small gathering of feral goats chill-out in the heather among the impressive falls at Inverarnan

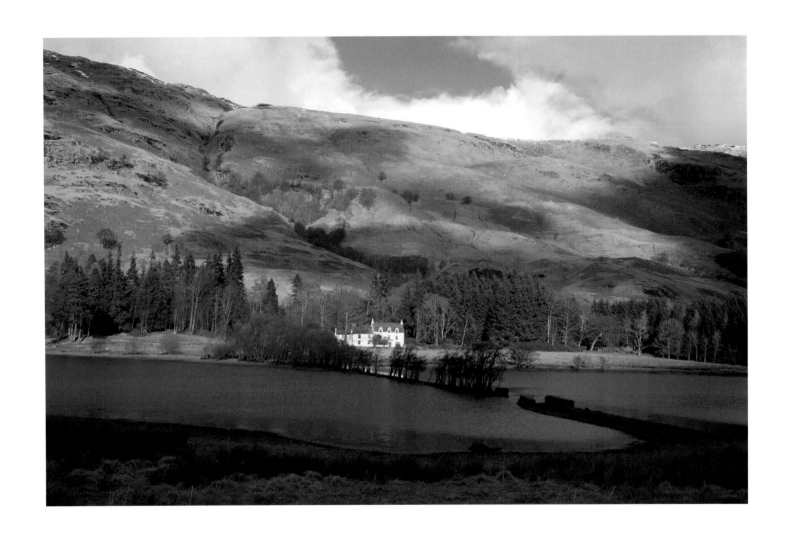

Over the mountains to the western end of Loch Katrine and you cannot miss the compelling architecture of Glengyle House, once lived in by Rob Roy McGregor

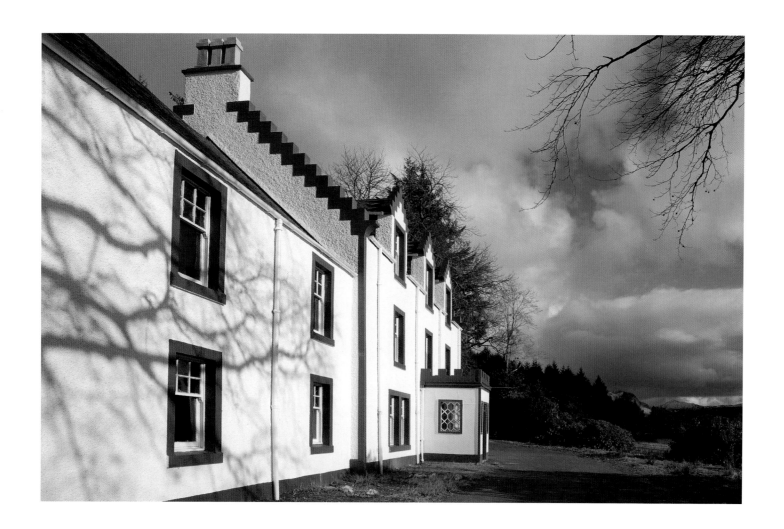

Closer in the dwelling has even greater presence

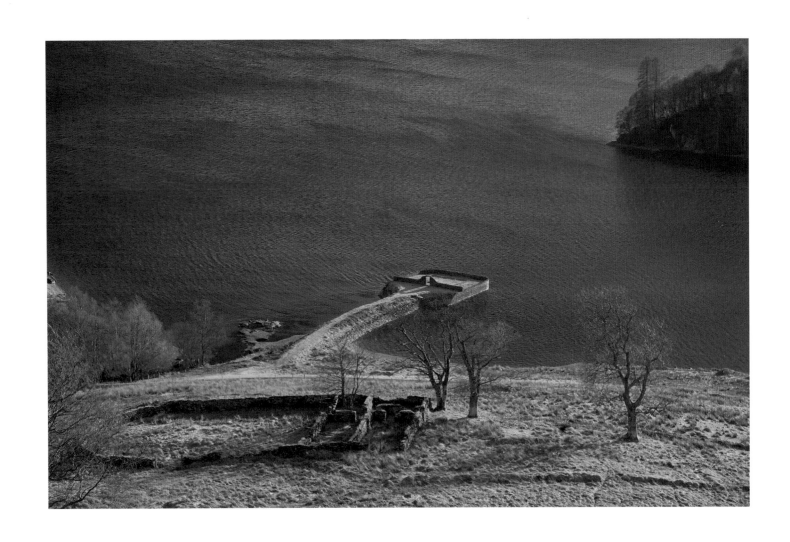

The Pier at Portnellen by the burial place of the Clan McGregor, Loch Katrine

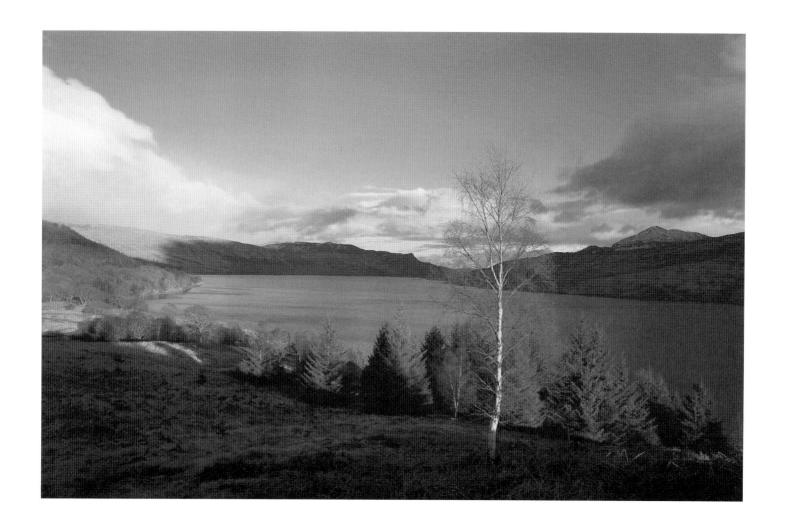

Loch Katrine near Strone

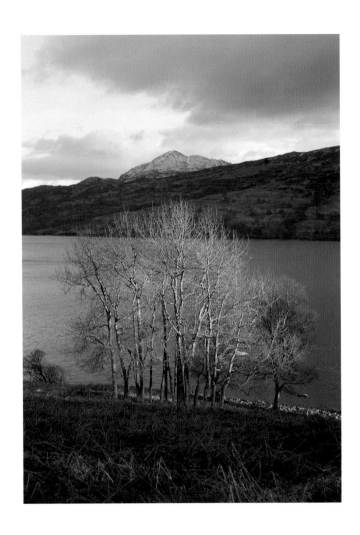

November on the banks of Loch Katrine with Ben Venue in the distance

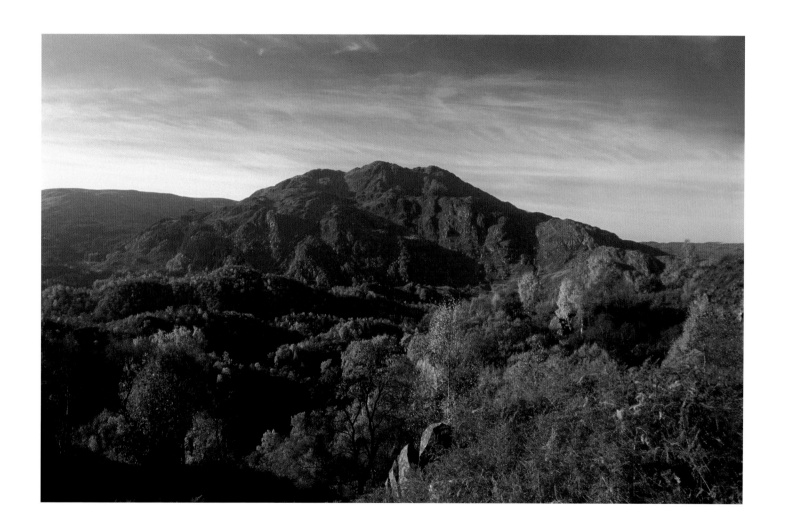

The mighty Ben Venue presides over the native woodland above Loch Katrine

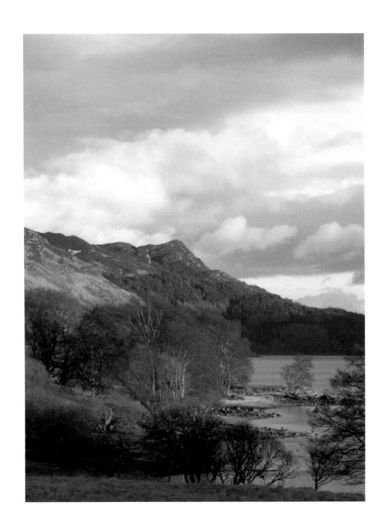

Strone on Loch Katrine and the lochside is radiant with autumn colour

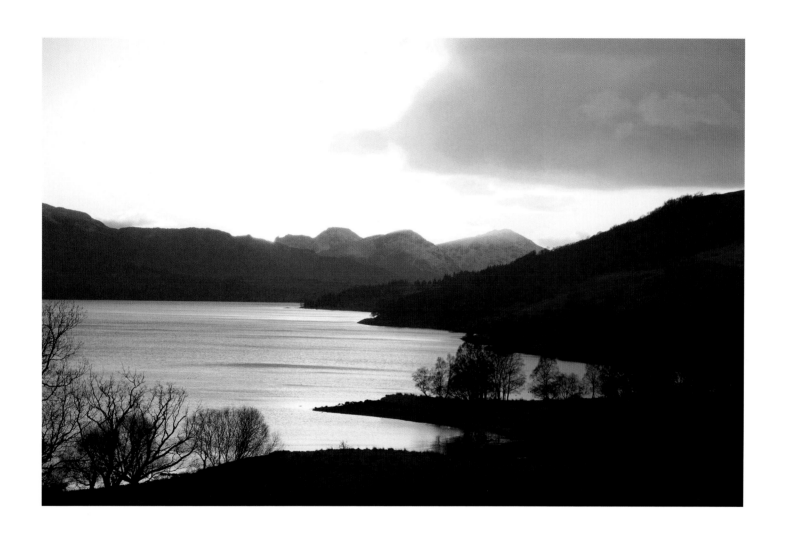

Sunset on Loch Katrine with a backdrop provided by the Arrochar Alps

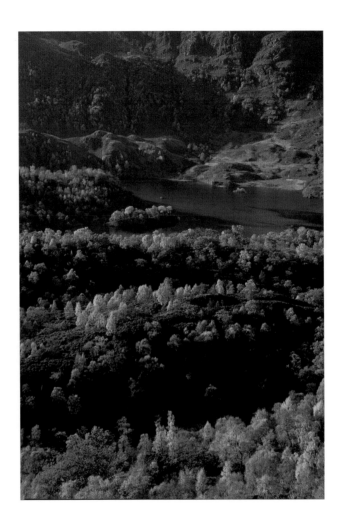

From Ben A'n golden birches decorate the wildwood above Loch Katrine

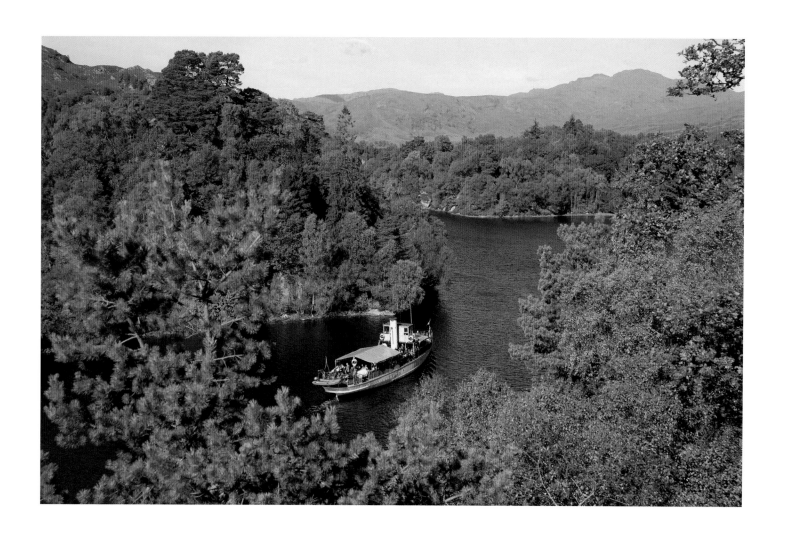

The SS *Sir Walter Scott* and its domain at Loch Katrine is one a Scotland's most enchanting features, where the age of steam is beautifully preserved and hard at work every day for the pleasure of its guests.

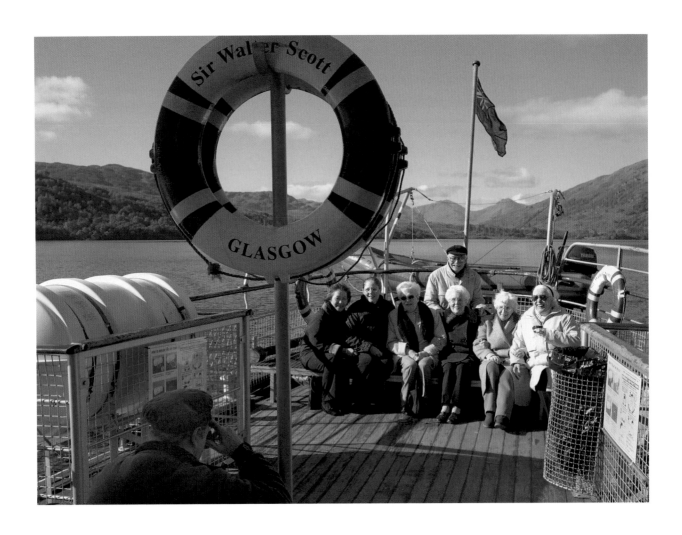

Trippers on the *Sir Walter Scott* and a sense of fun on the great day out

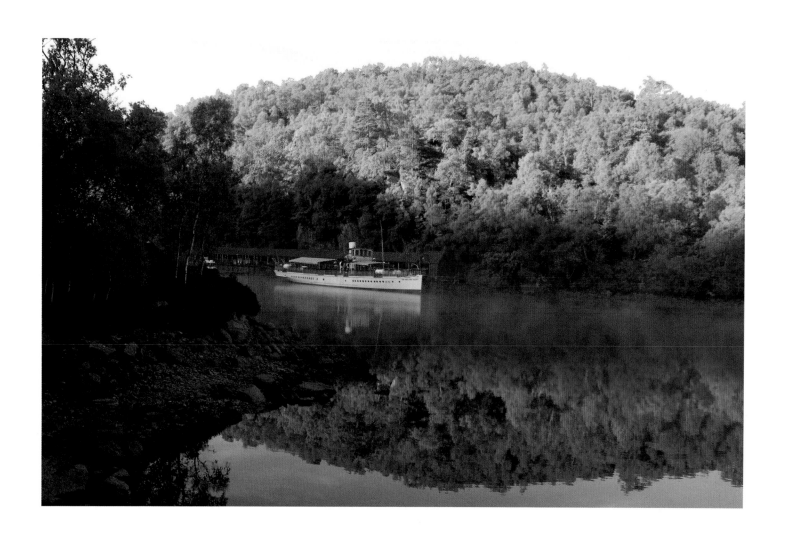

Vaporising water adds a touch of the fairytale to the *Sir Walter Scott* moored here at Trossachs Pier

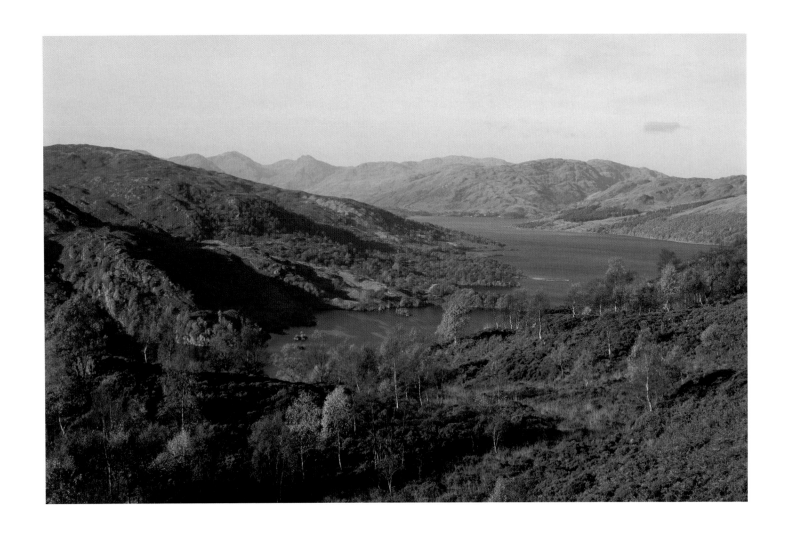

Loch Katrine vista, autumn

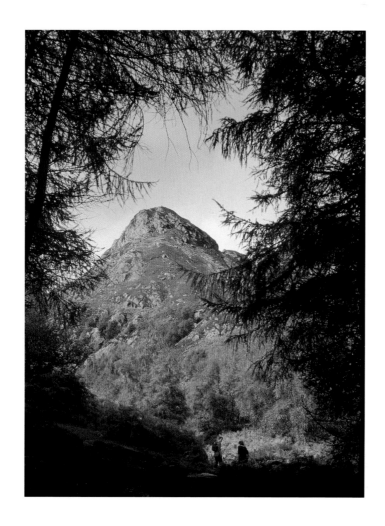

Ben A'n draws walkers like few other hills can, short and sharp, its knoll like summit beckons you out from the woods

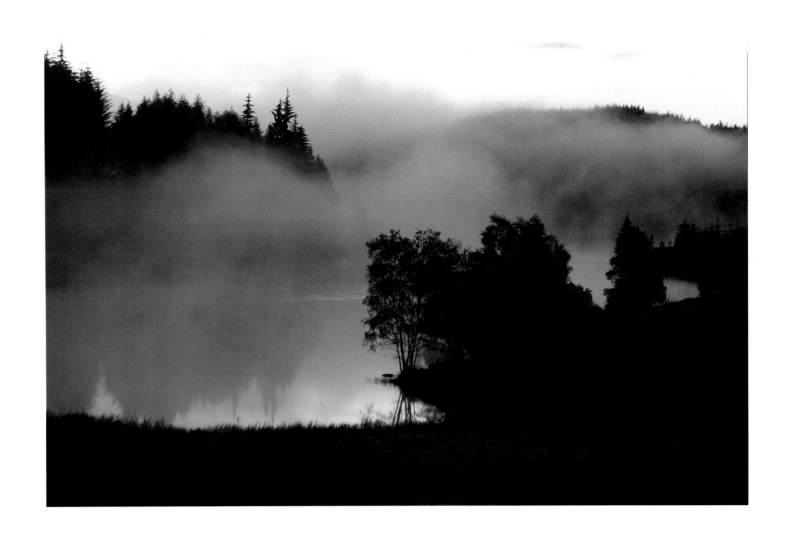

Sunrise and an ethereal mist emanates up from Loch Achray momentarily revealing an exquisite graphic detail

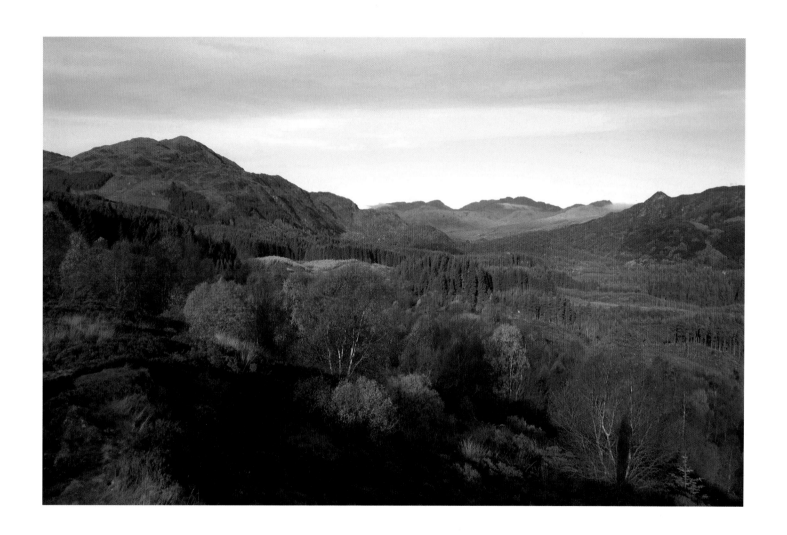

View from the official vista on Dukes Pass catches the essence of the Trossachs landscape

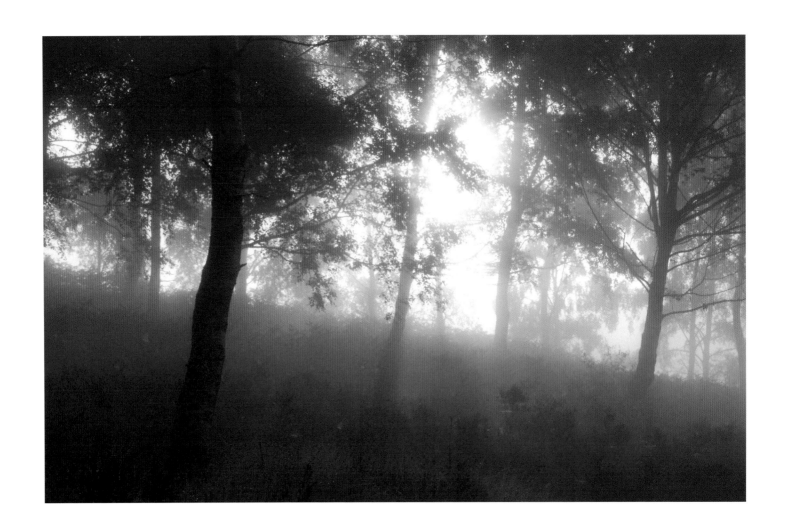

Sun burns through mist cloaking a small copse on Dukes Pass

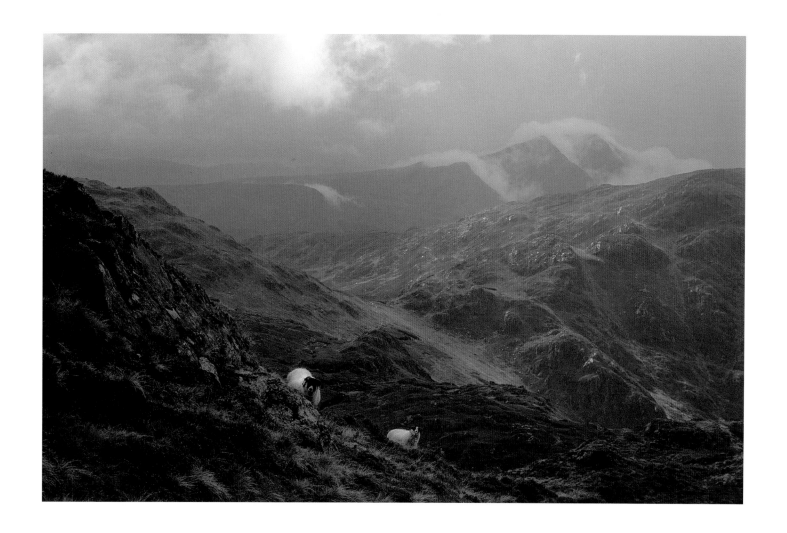

Low pressure envelops Ben Ledi. It is a tough hike but the cloud thins and the spirit of Rob Roy seems to fill the high moorland.

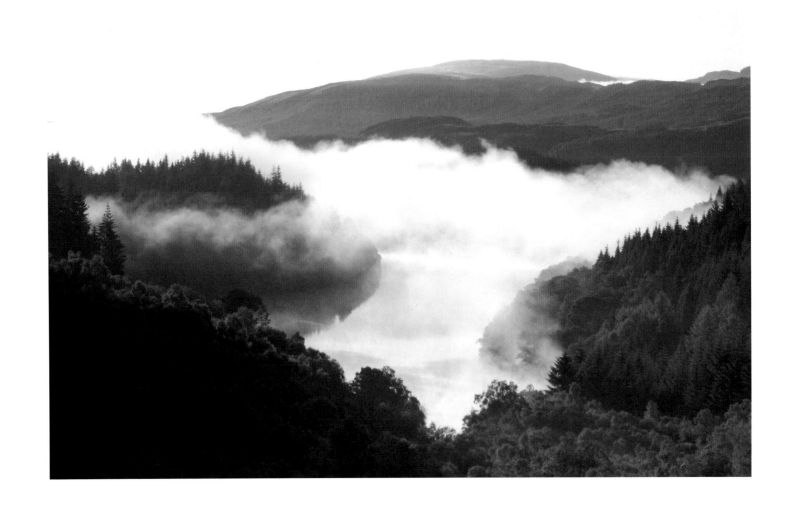

A luminescent morning mist rises from the evocatively named Loch Drunkie in Queen Elizabeth Forest Park

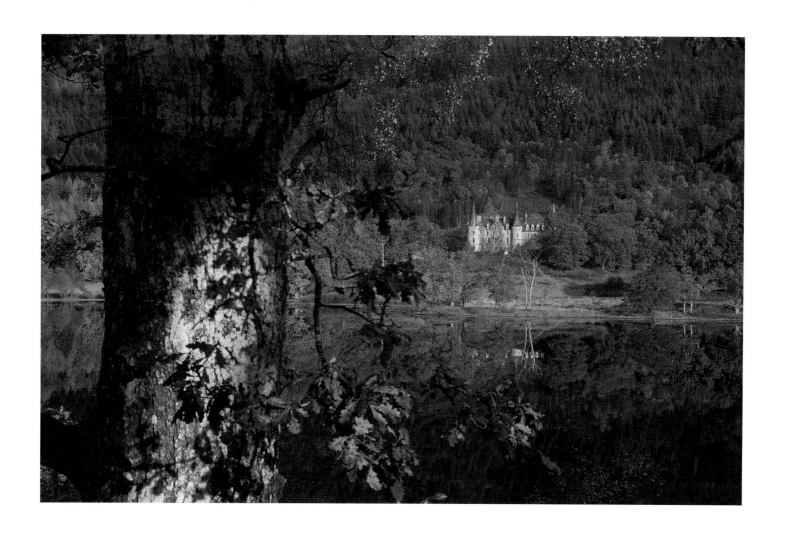

Climax autumn colour rages here at the epicentre of the Trossachs National Park, site of the Old Trossachs Hotel on Loch Achray

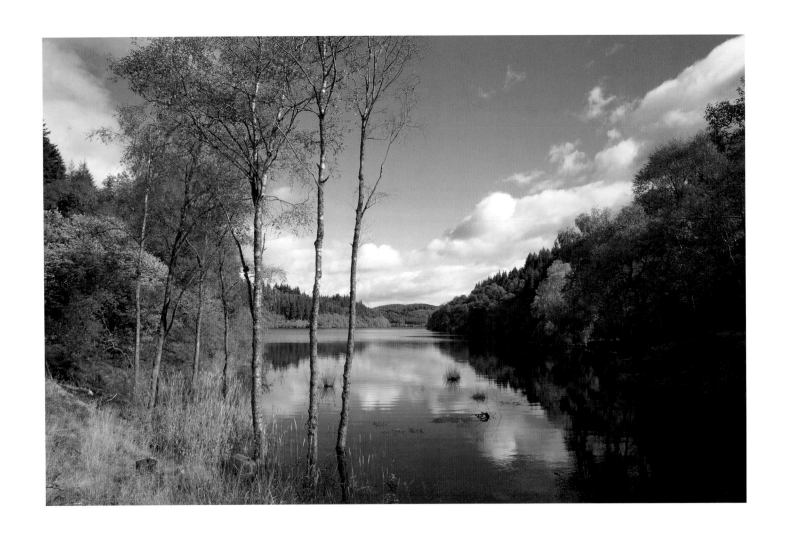

Loch Drunkie on the Forest Drive

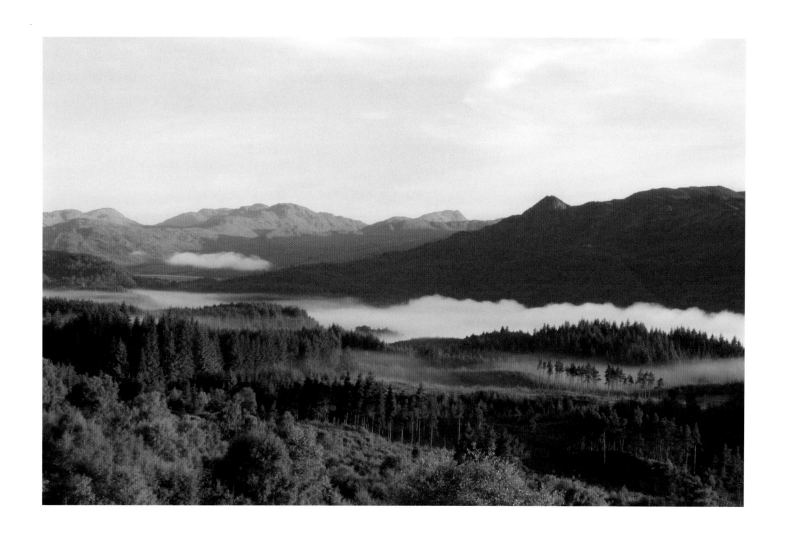

Gentle trails of morning mist linger over Achray Forest

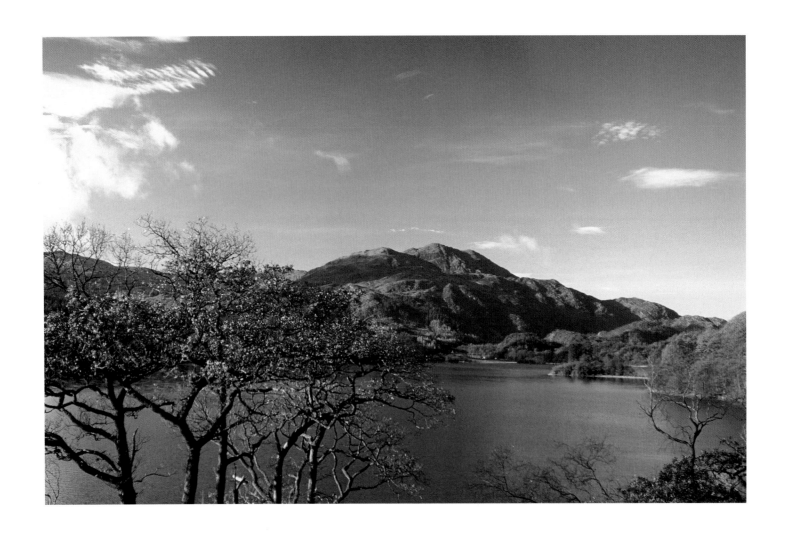

Loch Achray resplendent in October hues

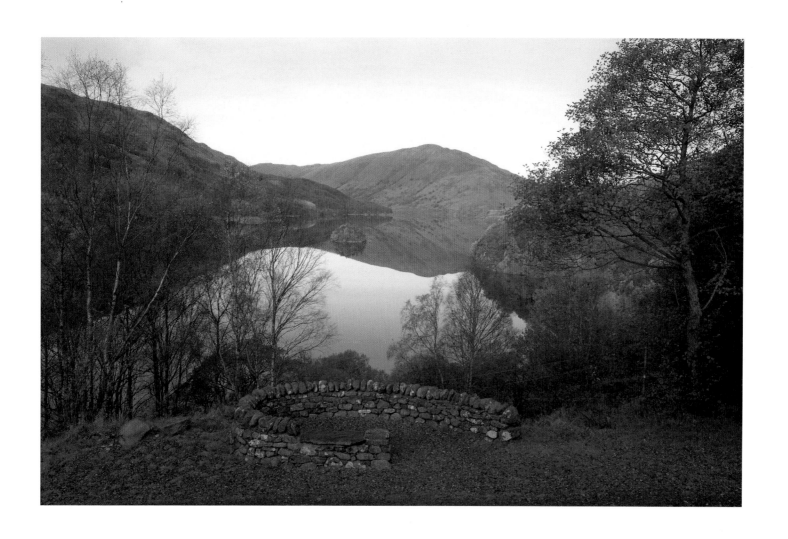

The Forestry Commission has become noticeably sensitive to public demand for landscape enhancement. Dry stone artefact, Finglas Reservoir

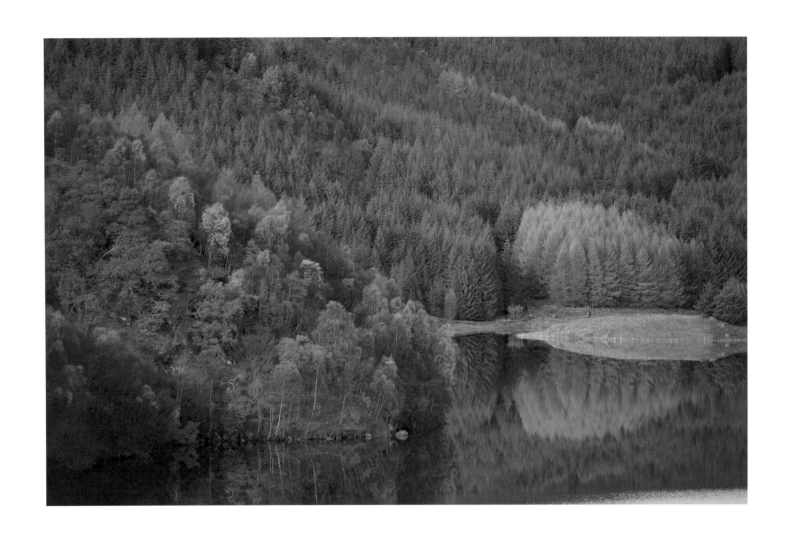

Planting for colour, Finglas Reservoir

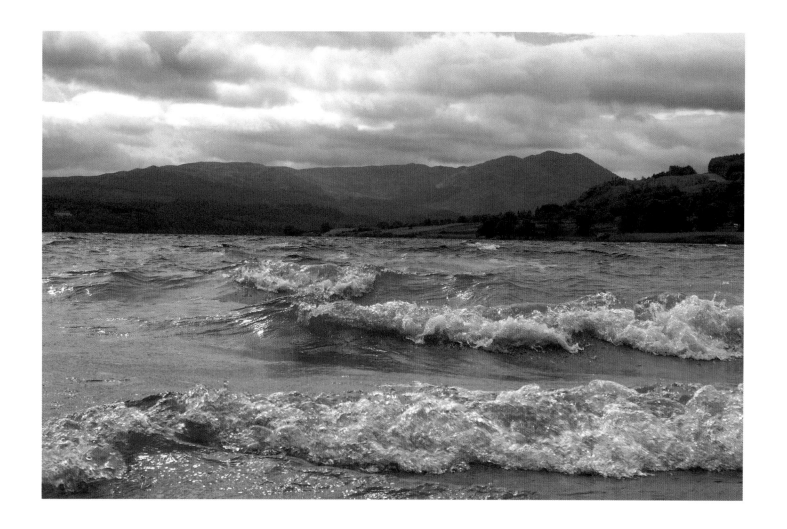

White-water on Loch Venacher

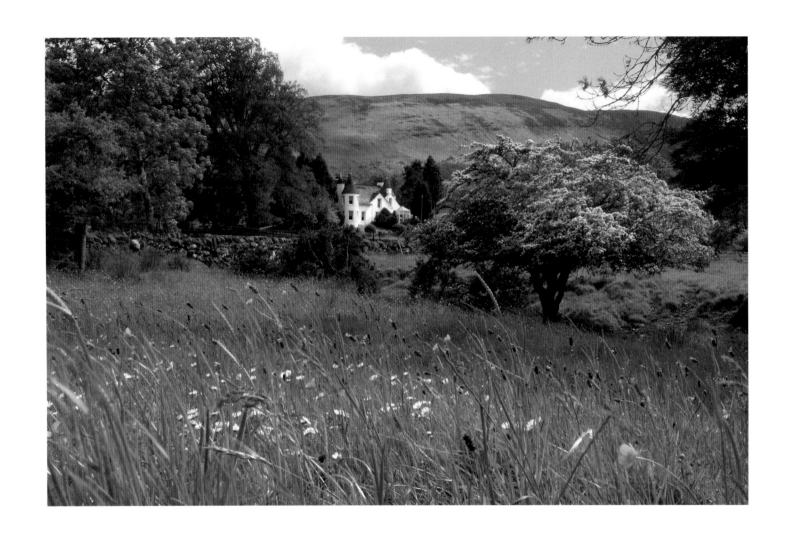

Idyllic dwelling, Invertrossachs

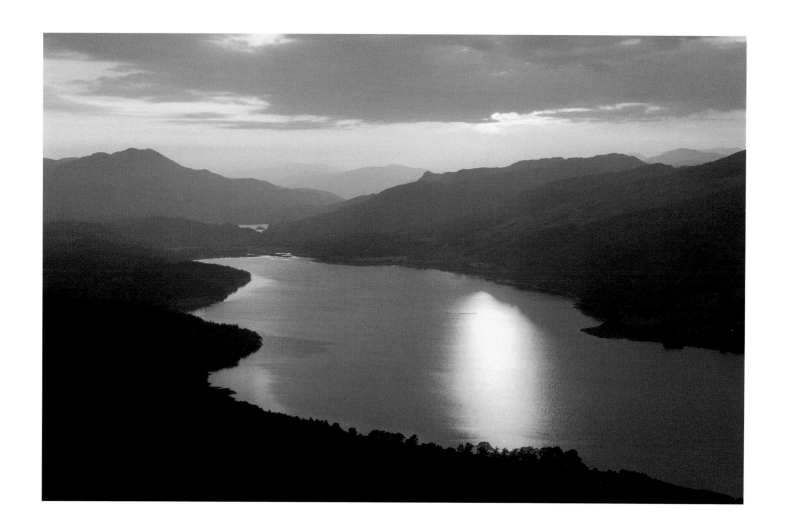

Gold on gold, Loch Venacher from Ben Gulipen

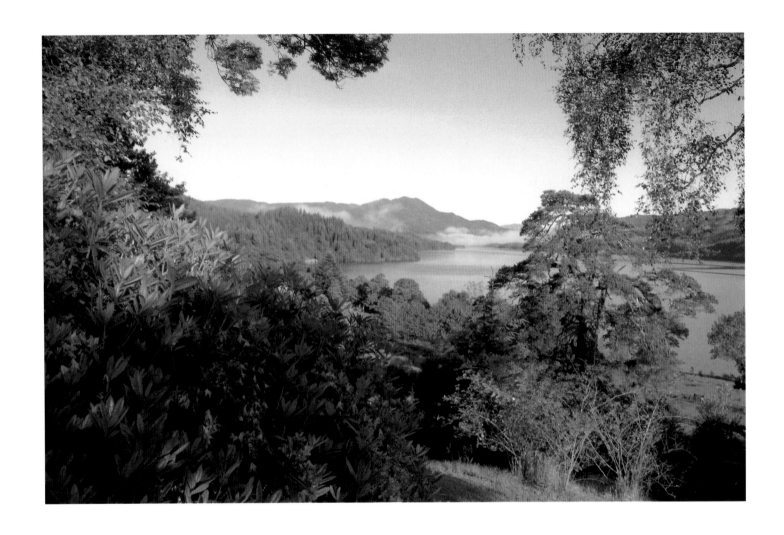

Lush garden habitat, Invertrossachs

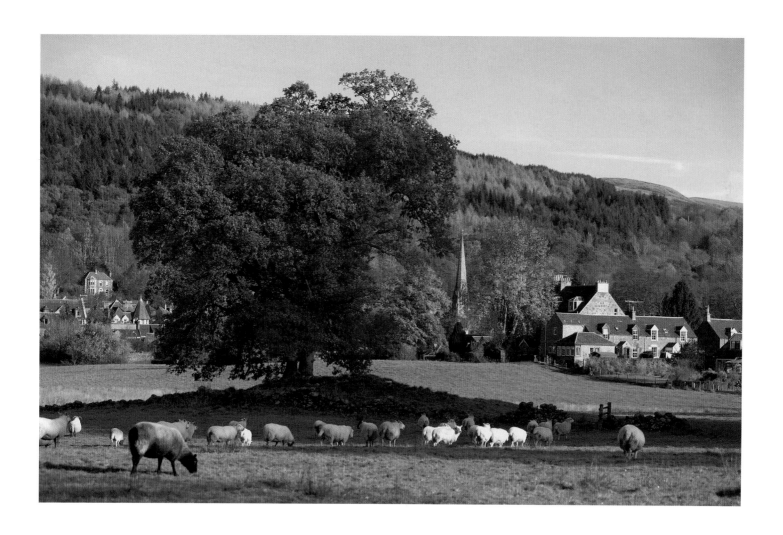

Callander has a more pastoral side

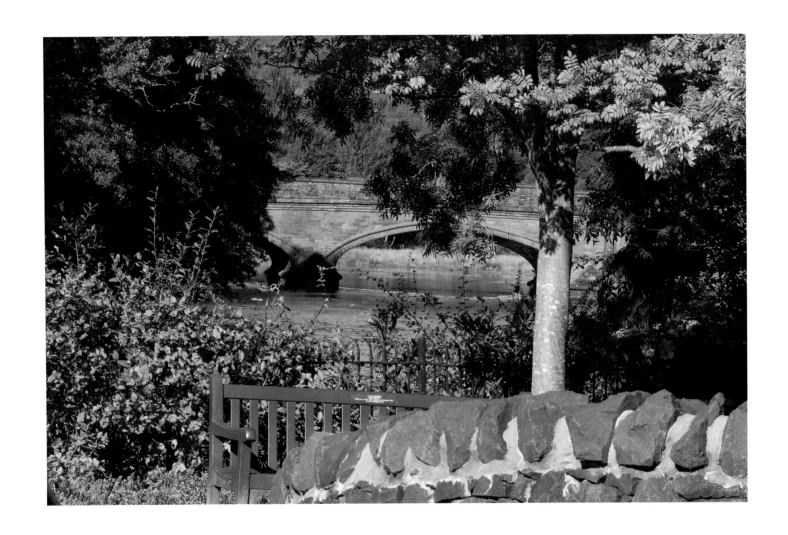

Callander, bridge detail

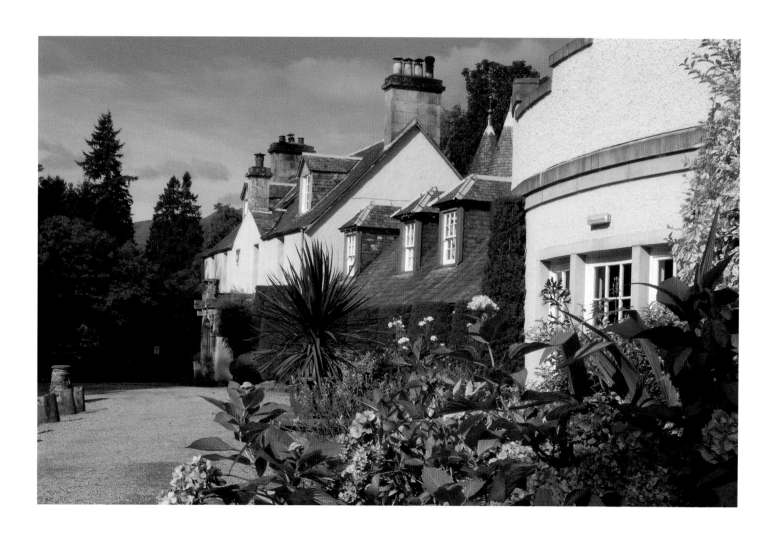

The Roman Camp Hotel, Callander

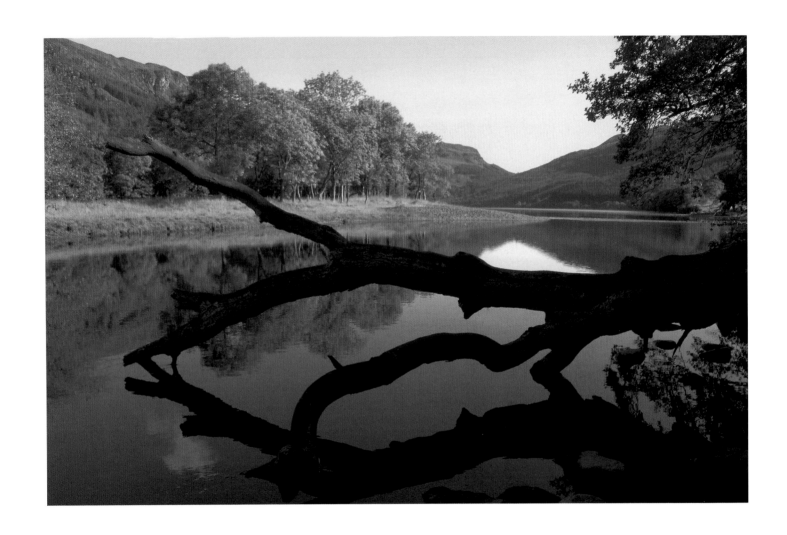

The outflow from Loch Lubnaig

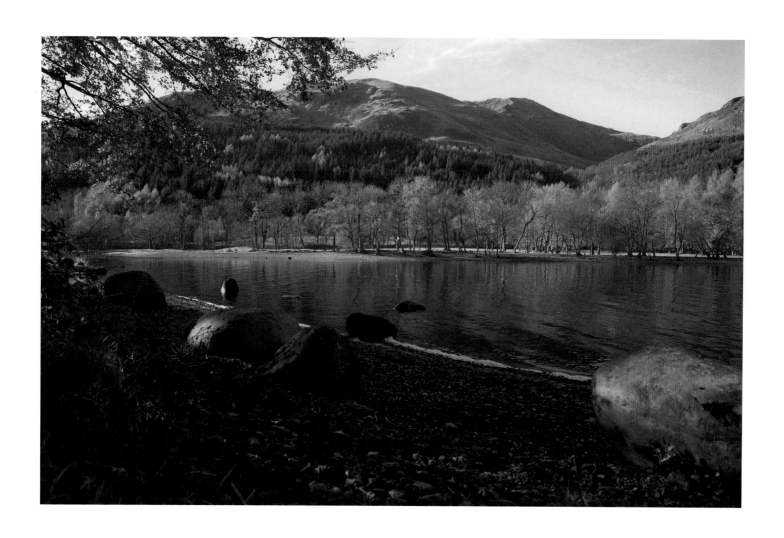

Crisp and tranquil, little Loch Lubnaig in autumn

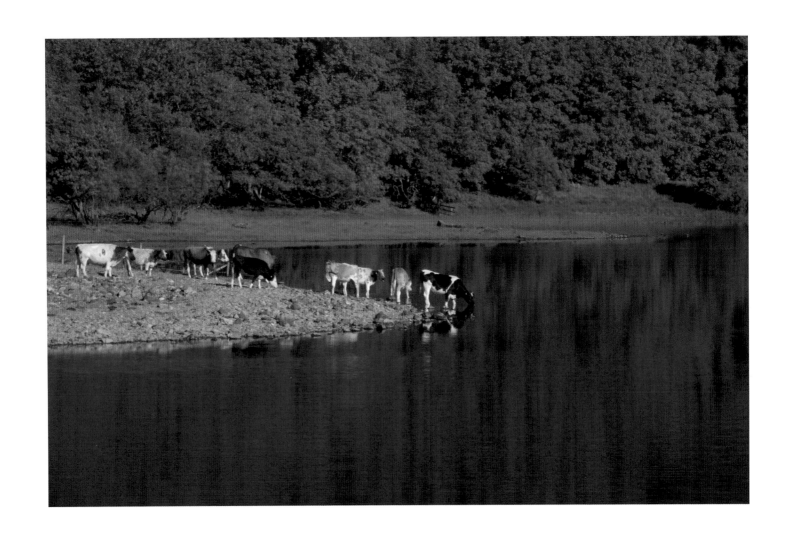

High summer on the western shore of Loch Lubnaig and cattle enjoy the crystal waters

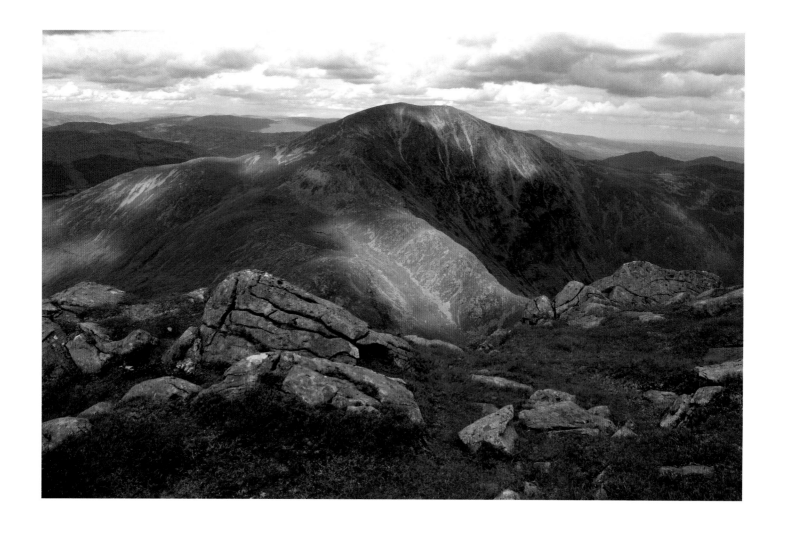

Mighty Ben Vorlich from Stuc a Chroin

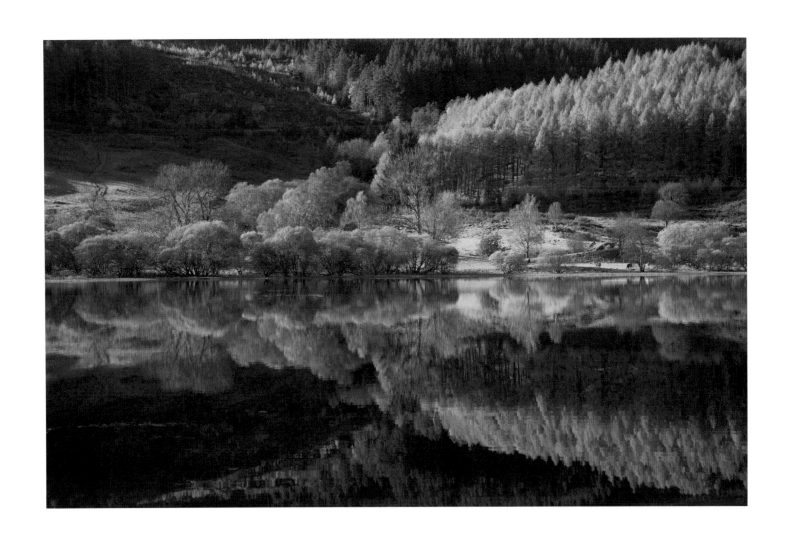

A rich tapestry of forest colour reflects perfectly in Loch Lubnaig

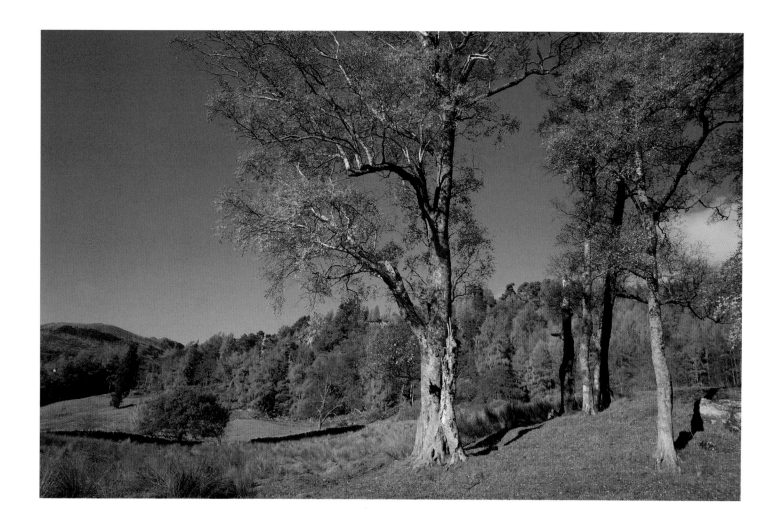

Birch Copse, Braes of Balquidder

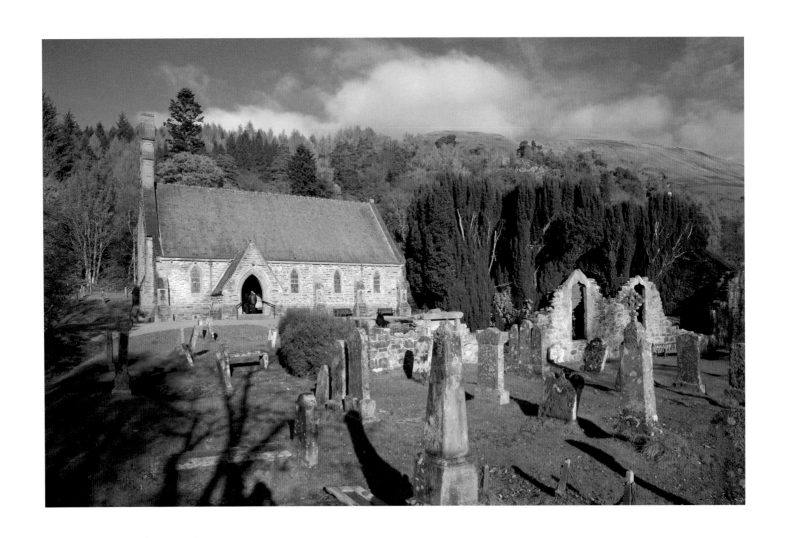

The church at Balquidder, handsome in its own right, also carries status as the burial place of Rob Roy McGregor

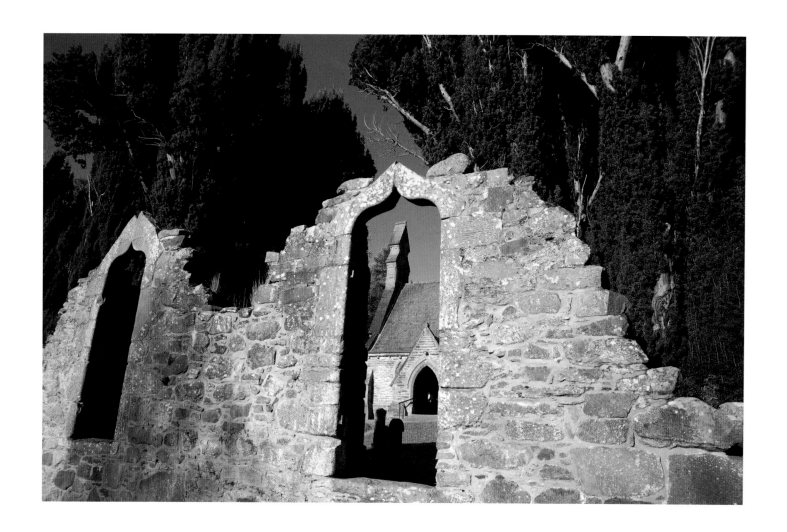

The graceful ruin of the former Balquidder Church sits easily alongside its successor

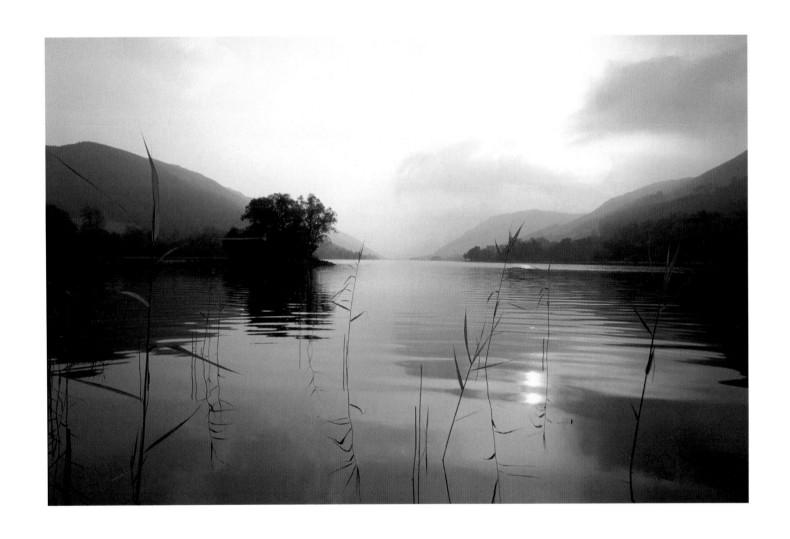

Sultry August light dances among the reeds, Loch Voil

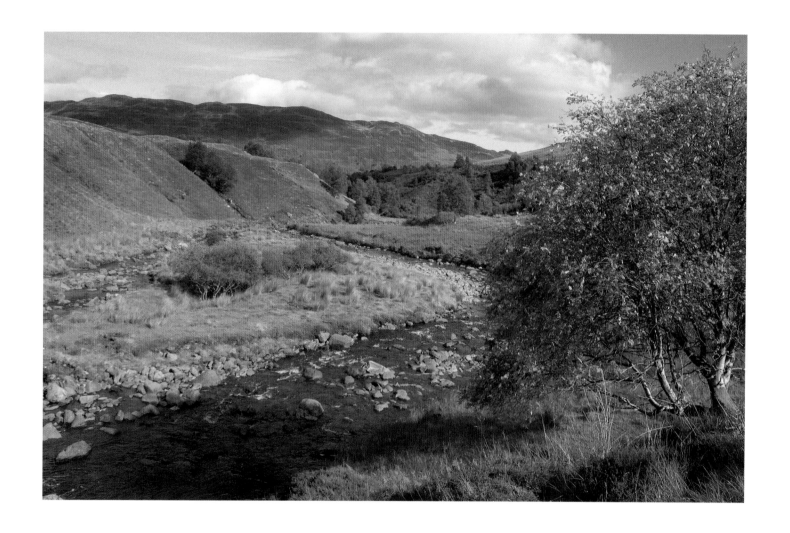

The Calair Burn, Glen Buckie

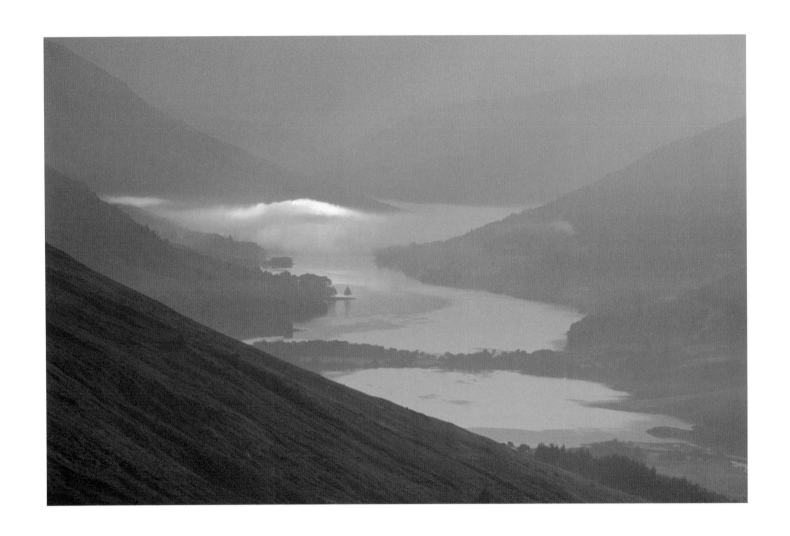

From the Braes of Balquidder magical light transcends the waters of Loch Voil

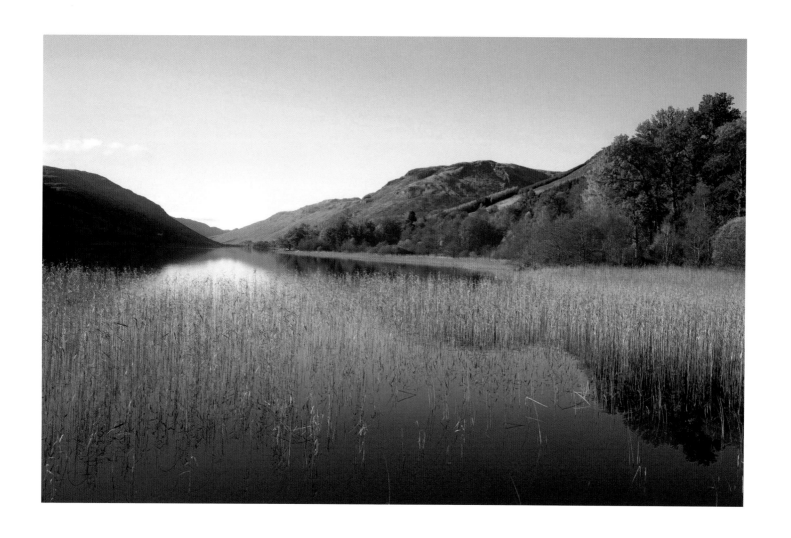

Loch Voil in autumn. This loch seems to do tranquility well in all seasons.

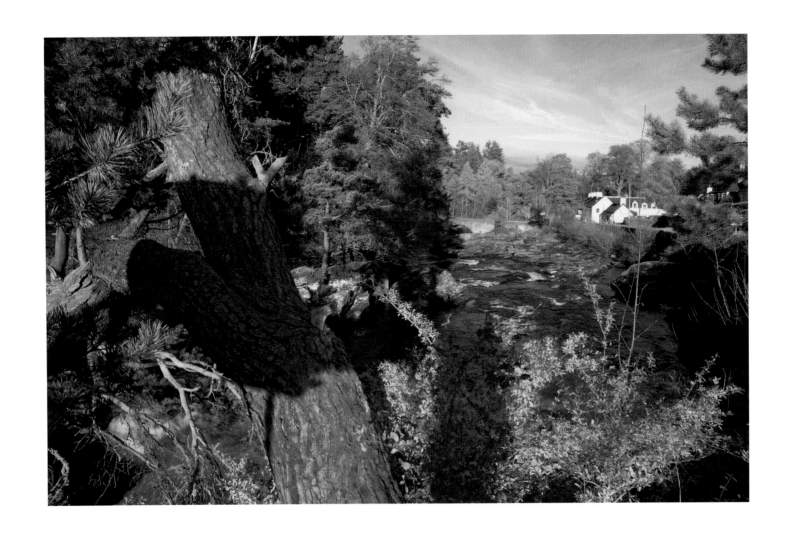

An abundance of colour and texture from the noble Scots Pine, Falls of Dochart at Killin

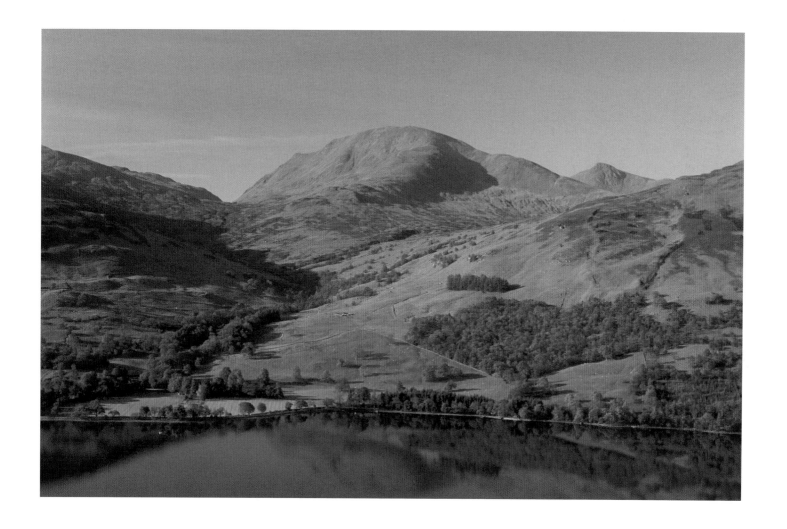

Ben Vorlich rises above Loch Earn

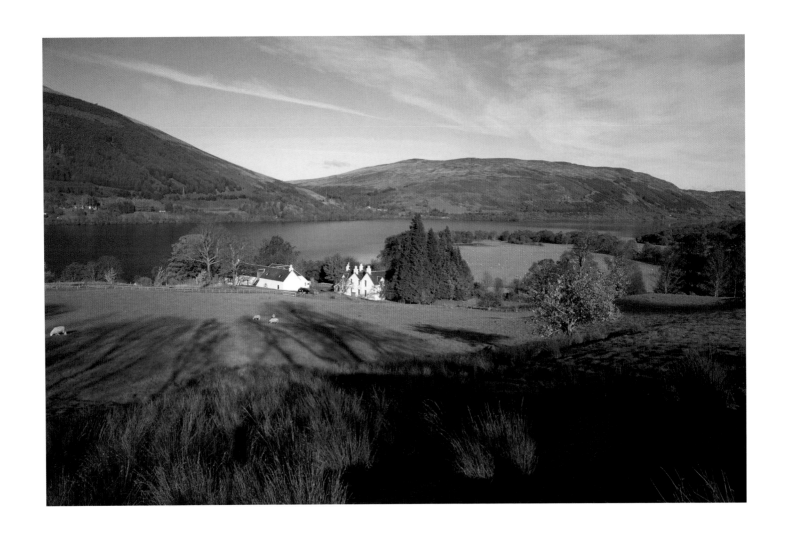

Farm at Edinample, Loch Earn

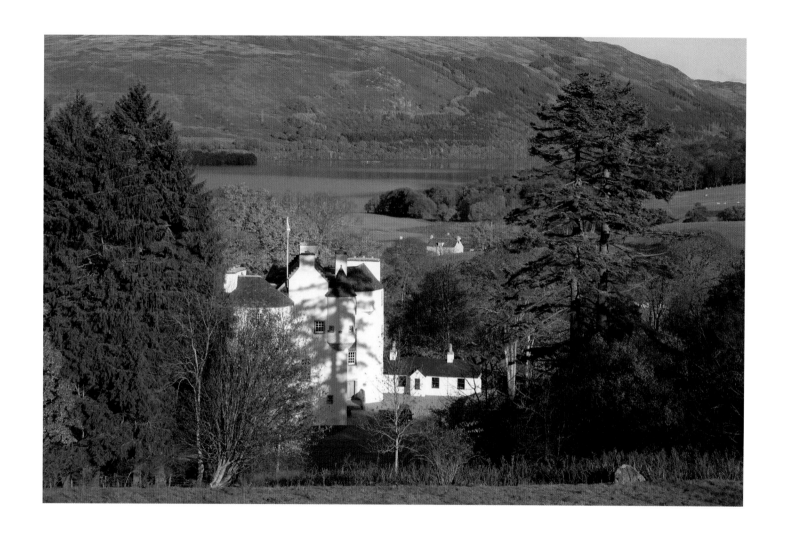

Edinample Castle, Loch Earn

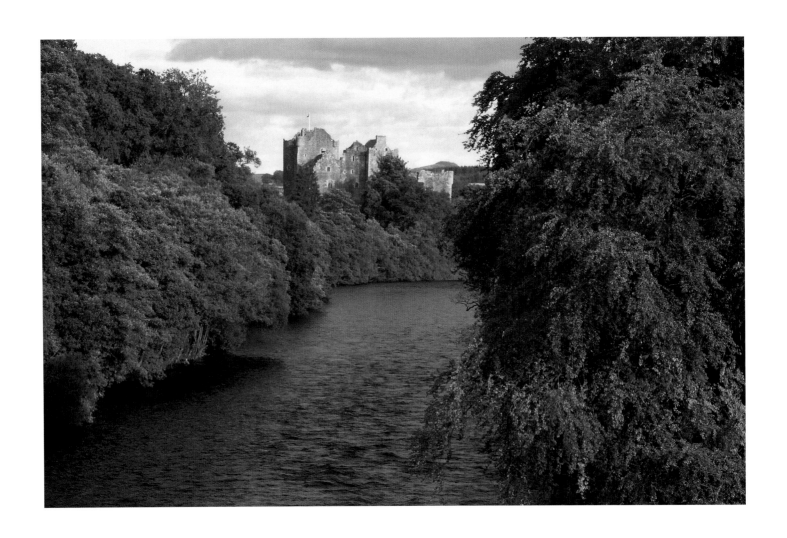

Doune Castle and the River Forth

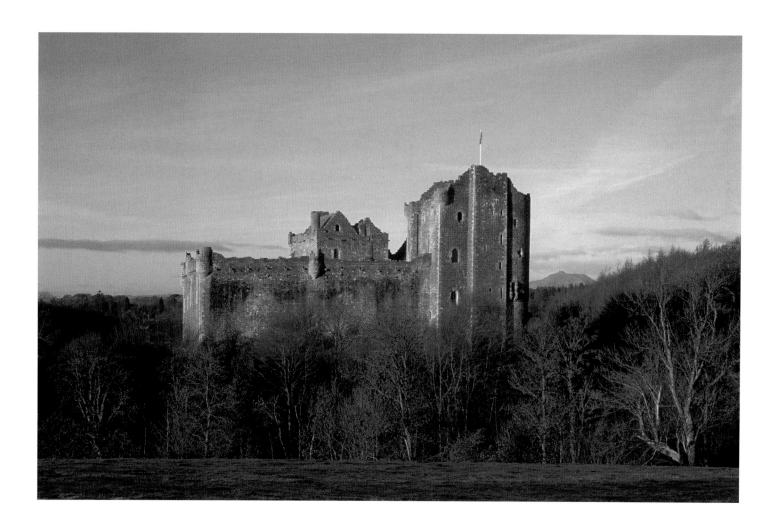

Doune castle in winter

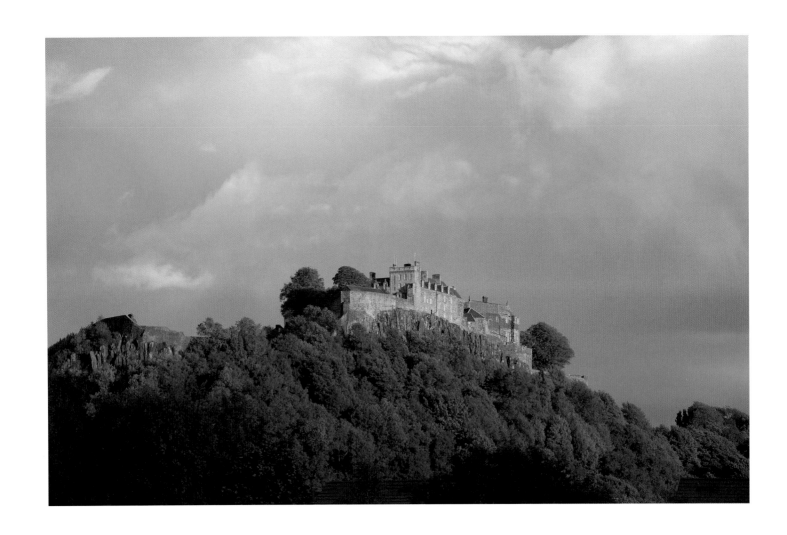

A complex sky sets the stage for the fortress posture of Stirling Castle

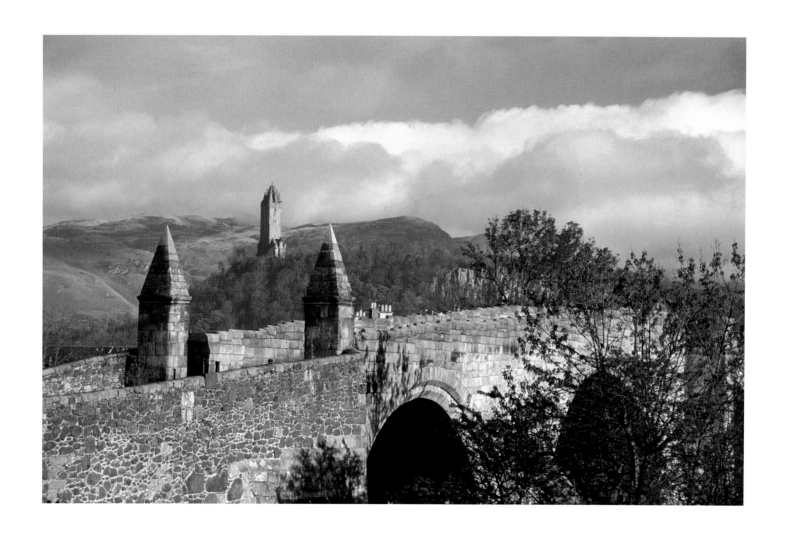

Old Stirling Bridge and its spatial relationship with the Wallace Monument

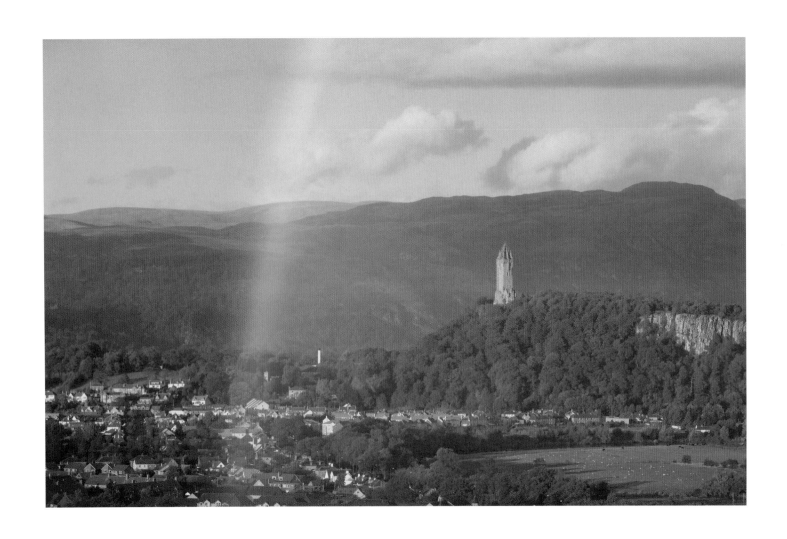

Glamorous Scottish weather. The Wallace Monument from Stirling Castle.

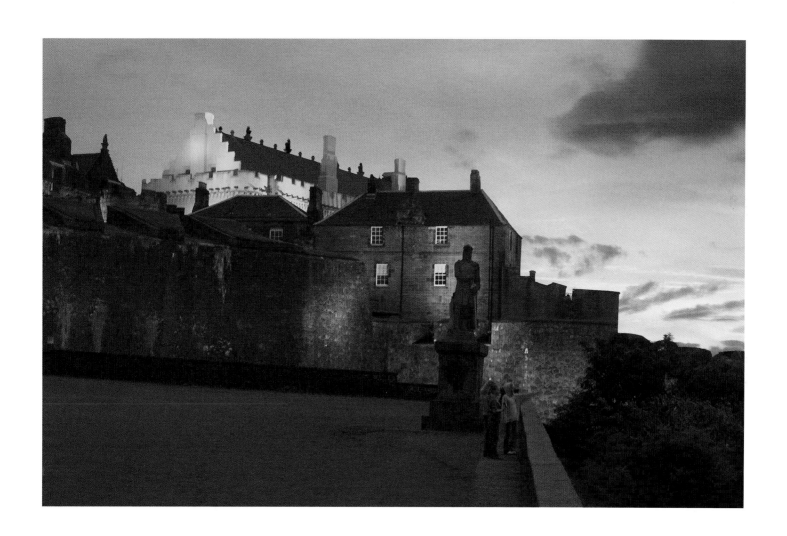

The esplanade at dusk, Stirling Castle

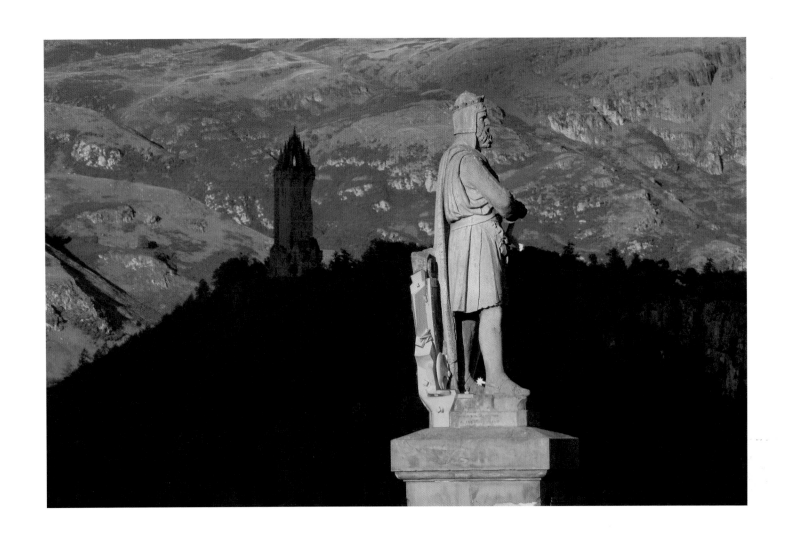

Bruce and Wallace, Castle esplanade

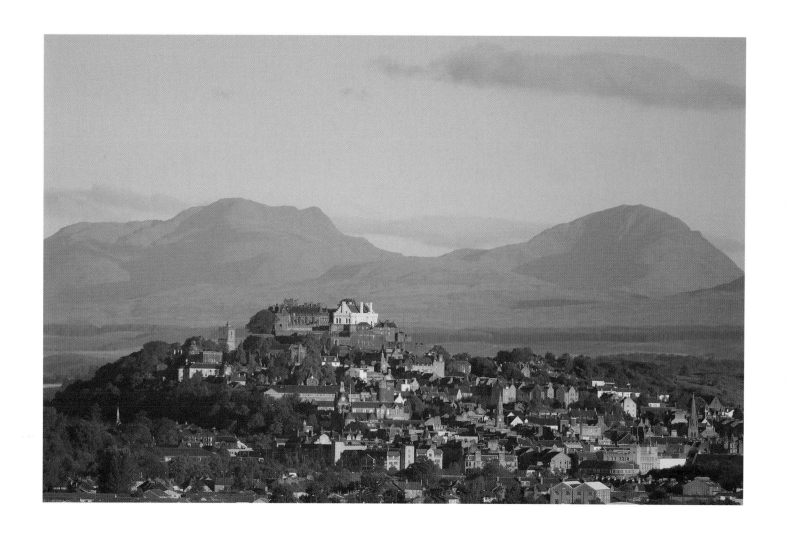

Stirling Town from Bannockburn

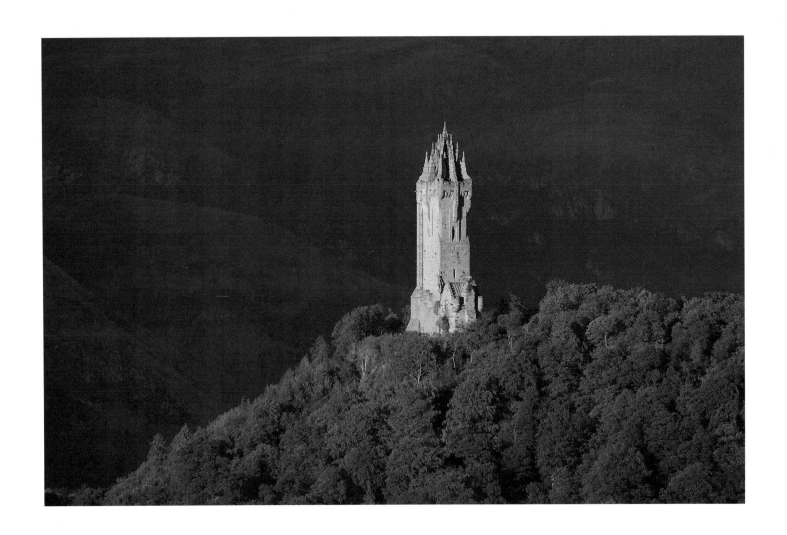

The Wallace Monument